SHAPED BY LOVE

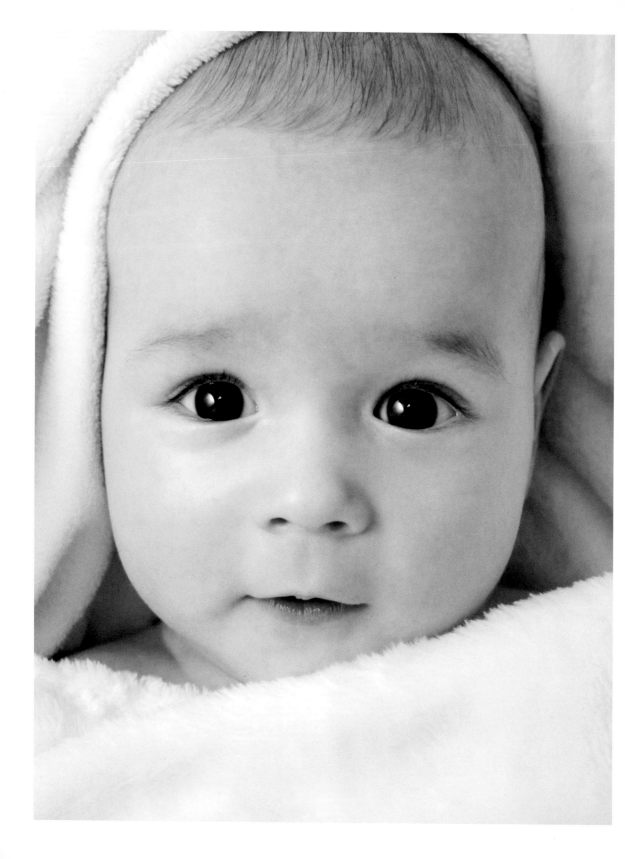

SHAPED BY LOVE

The Extraordinary Impact of Nurturing

AMY HATKOFF

Abrams, New York

THIS BOOK IS A TRIBUTE TO ALL
PARENTS WHO CAN CHANGE
THE WORLD THROUGH THEIR
LOVE. IT IS DEDICATED TO MY
SIBLINGS, SUSAN PATRICOF AND
CRAIG HATKOFF, WHO BOTH
MASTERED THE ABILITY TO LOVE
UNCONDITIONALLY.

CONTENTS

INTRODUCTION

Over the past decade, there has been an explosion in the scientific research about what babies and young children need for positive outcomes in every area of development. *Shaped by Love* translates these groundbreaking findings into a language that is easy for parents of all backgrounds to understand and bring to everyday interactions with their children. Each chapter offers insights and tools to help parents and caregivers lay the foundation for healthy patterns that can last a lifetime.

Today's technological advances can track how babies' brains develop. MRIs and PET scans are now able to identify the impact different experiences have on specific areas of the brain. These findings confirm that relationships shape the brain. Early, secure attachments and sensitive, nurturing interactions lead to optimal development in all areas including social, emotional, cognitive, psychological, physiological, neurological, and immunological processes.

No matter how complicated the scientific terminology may seem, the conclusion is that simple, everyday interactions in the first years of life shape learning and development. Hugs, smiles, kisses, and empathic responses, for example, have been found to do more for brain development than structured learning activities. Warm, affectionate responses foster positive characteristics, including confidence, curiosity, self-control, relatedness, and cooperativeness. These qualities are considered by Early Head Start to be more important to school readiness than knowledge of numbers and letters. Nurturing, supportive interactions help children concentrate, think more clearly, set and achieve goals, and form healthy relationships.

At birth, the brain is only 25 percent developed and contains hundreds of billions of brain cells, or neurons, the majority of which are not yet connected.

Almost 90 percent of brain development occurs by the age of three. *Shaped by Love* is designed to raise parents' awareness of the importance

of the first years of life and, in light of these critically important findings, highlight the positive impact of sensitive, warm responses on a child's development as well as the negative impact of stressful ones.

The content in *Shaped by Love* replaces misconceptions about child development with scientific findings. For example, while a large percentage of the population believes that picking babies up when they cry in the first months of life will spoil them, science can now show that cortisol, the hormone that is released when babies are stressed, is detrimental to a baby's brain architecture. Rather than spoiling babies, soothing reactions wire babies to manage stress and control their impulses throughout their lives. Responding to babies' cries helps them develop trust, feelings of well-being, positive expectations, and self-reliance. Attuned, nurturing responses stimulate the development of the higher brain, which controls such functions as cognition, memory, language development, planning, reasoning, decision making, and more.

Shaped by Love also provides parents with critical information about the kinds of behavior infants and toddlers are capable of at different stages. A national study found that parents often expect children to be able to share, control their impulses, or wait their turn, for example, long before they are developmentally capable of doing so. Knowing what children are capable of doing at different stages can help parents set realistic expectations that can support rather than unintentionally interfere with children's growth. Information about stages of child development can make parenting easier and less stressful.

The goal of *Shaped by Love* is to saturate the culture with this essential information that can have profound and lasting effects on children's well-being. The importance of nurturing relationships is beginning to be recognized by not only psychologists and early childhood educators, but also economists and politicians. If we widely disseminate the lessons from the science on early childhood development and institute programs that enhance parents' nurturing capacities, we can create positive outcomes for children and ultimately more peaceful, cooperative, and productive communities.

·1·

KNOWING
NEWBORNS

We often underestimate newborns. In this chapter they show us their surprising capacities and share that they are social beings ready to connect and communicate with their parents from the moment of birth. These interactions with their parents stimulate brain development and help the newborn begin to develop a sense of self.

Babies' brains grow more during the first three years of life than in any other period. By the time a child is three years old, 90 percent of her brain will have developed. While babies are born with hundreds of billions of brain cells, only a small percentage are connected. These connections are developed through the newborns' everyday interactions with their parents.

I AM BORN LOOKING FOR YOU!

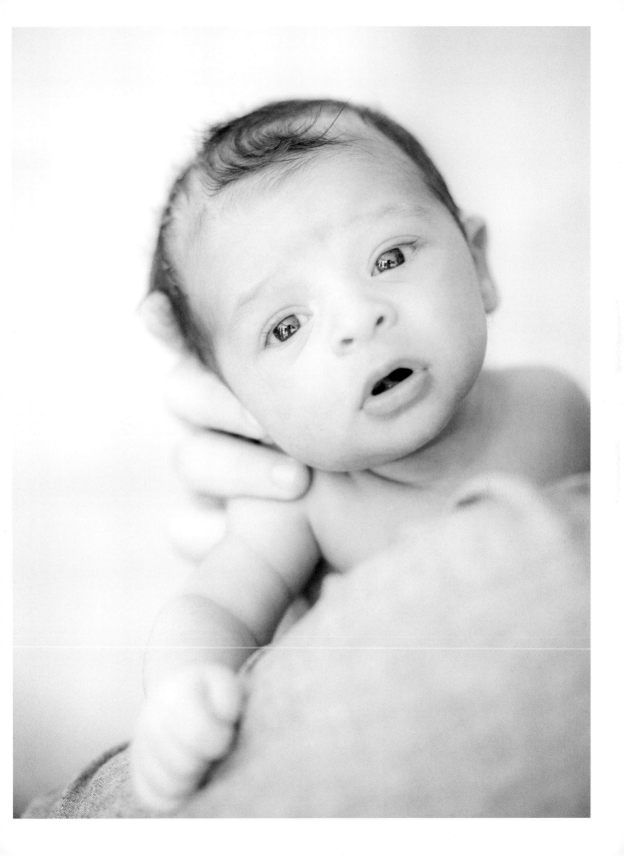

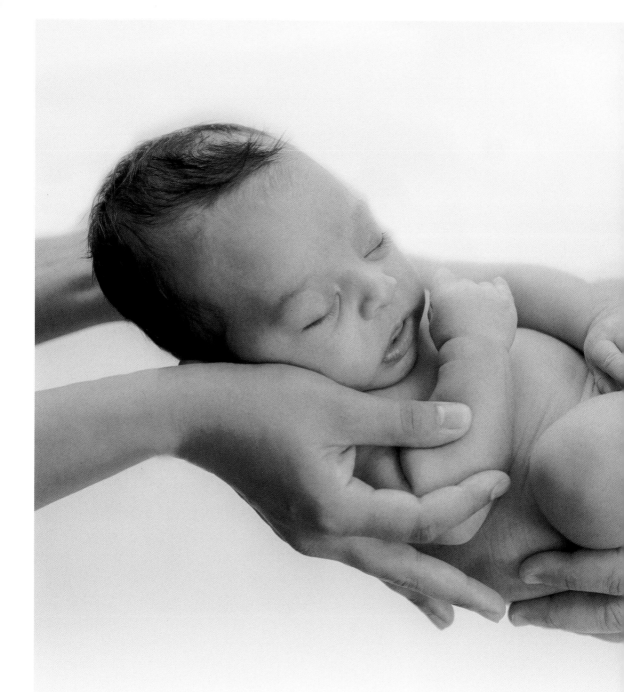

OUR RELATIONSHIP
SHAPES ME.

It is important to recognize the capacities of newborns and understand how ready they are to communicate with us from the start. We need to realize how present they are and enter into an interactive dance with them. Reading newborns' cues, responding to the different ways in which they reach out to us, staying attuned to their efforts to communicate with us, gazing into their eyes, matching their levels of excitement, and all the other moment-to-moment interactions we have with them help to shape who they become. We are their world. They become themselves through their interactions with us.

Newborns seek and need contact and communication with their parents from the moment of birth. They are hard-wired to connect. They become familiar with the sound of their parents' voices in the womb and recognize and turn toward them shortly after they are born. They also are familiar with and able to recognize their mother's scent. Newborns can imitate their parents' facial expressions soon after delivery. These first interactions with parents stimulate brain development and the formation of the newborn's sense of self.

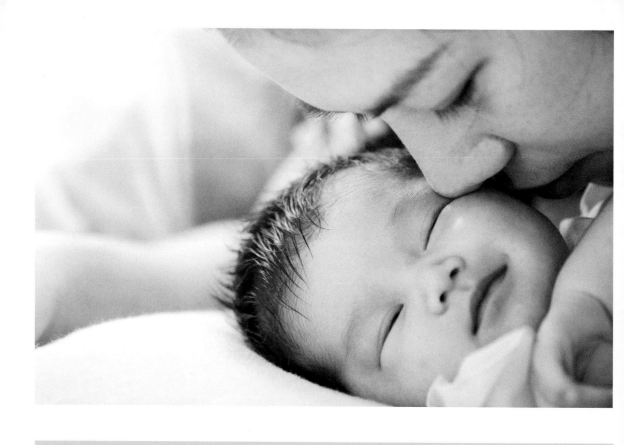

JUST BEING WITH YOU
HELPS ME DEVELOP IN
EVERY WAY.

YOU ARE THE ARCHITECT
OF MY BRAIN

At birth, the newborn brain contains more than 200 billion brain cells, or neurons, but only a small percentage are connected. Newborns make more than one million neuronal connections a second. These connections, or synapses, develop through the give-and-take of relationships. Just *being* with a parent stimulates these connections. Parents and caregivers are being recognized as brain architects.

Today, with the explosion of information on how babies' minds develop and the recognition that they are more capable than we previously thought, there is a great deal of pressure on parents to stimulate their learning processes.

Recognizing and responding to a baby's cues have been shown to be more important to a baby's brain development than organized learning activities. Babies who feel understood learn more easily, have a positive sense of self, develop empathy, and can decipher the social cues of others. As babies are seen and heard and responded to sensitively, they begin to gain experience and knowledge of who they are.

WHY SEPARATING IS SO HARD TO DO!

One of the more challenging issues about parenting today is managing our responses to our babies' cries. It may be helpful to keep in mind that a baby's cry upon separation is a universal response. Babies are actually hardwired to cry when separated from their parents. In primitive times, crying had a lifesaving purpose, as it helped a parent locate and bring their baby to safety. Although the dangers of the past may be gone, the primitive wiring still remains. Over time, as we soothe babies and help them settle, they begin to develop the capacity to soothe themselves. Babies are also hardwired to stop crying when they are picked up. A team of Japanese researchers found that when infants are picked up and carried by their mothers, there is an instant calming effect. They recognize this as a universal phenomenon that affects all infants.

THE POWER OF
SOOTHING INTERACTIONS

One of the most important goals in the first three years of life is to help the higher brain gain control over the lower, more emotionally driven areas of the brain. When we comfort babies, we help wire their brains to release hormones that create feelings of well-being and happiness.

At birth, the primitive areas of a baby's brain are in control. Only a small portion of the higher brain, which controls functions including judgment, planning, and decision making, is wired. Warm interactions activate neurons in the higher brain, enabling it to gain control over the areas that are driven by impulse and emotion. When a baby is not soothed and responded to sensitively, the primitive areas can stay in control, making it difficult for a child to manage emotions and stress throughout life.

Children whose cries are met consistently and promptly in the first quarter of the first year cry less and sleep better in the rest of that year. Babies who elicit responses tend to develop into independent, confident, and self-reliant children.

ANSWERING THE CRY

In the same way that babies are hardwired to cry if separated from their parents, maternal responses to infants' cries are also hardwired. A study of mothers from eleven countries showed that the same areas of all the mothers' brains were activated in response to their babies' cries. All of the mothers responded by picking them up and either holding or talking to them.

I AM READY TO CONNECT WITH YOU FROM THE MOMENT OF BIRTH AND BEFORE.

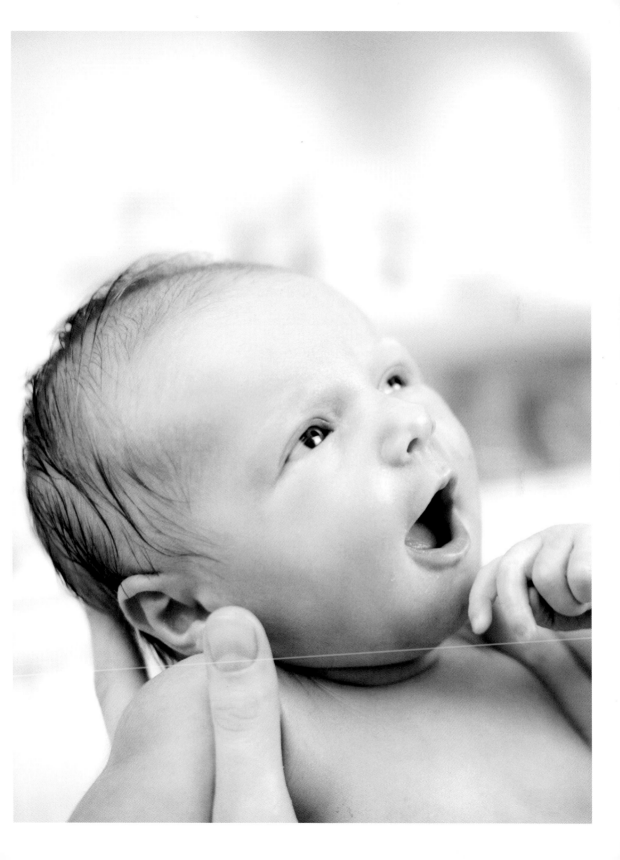

COMMUNICATING WITH NEWBORNS

We tend to think of newborns as helpless and without intention while in fact they have surprising abilities. They are already gifted communicators at birth. Babies begin to form the foundations for sounds and language while in the womb and can detect nonverbal signals before they can speak. They are wired to learn every language in the world at birth, a capacity that is lost if not used! At just four days old, newborns are able to distinguish their native language from a foreign one. Their hearing is very acute, enabling them to detect a missing beat in a musical pattern. Newborns' facility with language speaks to the importance of talking to them even while they are still in the womb.

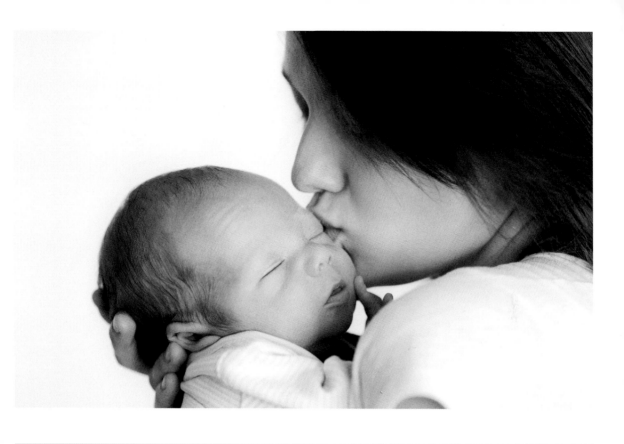

I ALREADY KNOW THE
SOUND OF YOUR VOICE.
I COULD HEAR YOU
IN THE WOMB.

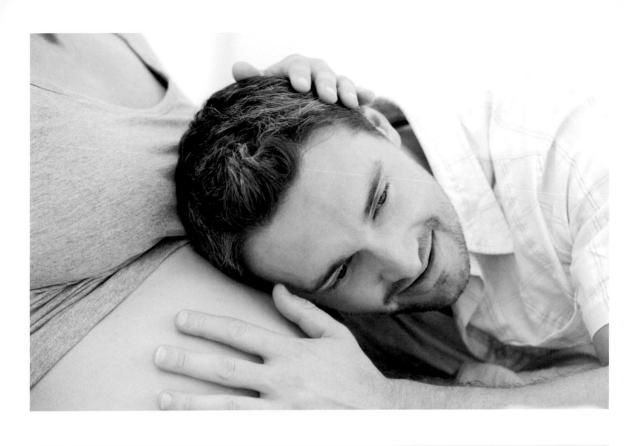

TALK TO ME!

I AM LISTENING

At around 25 weeks in the womb, hearing begins to develop and babies hear their parents' voices. This can be comforting and provide a sense of security. Babies can also sense and be affected by a parent's emotions even while in the womb: Having heard their parents' voices at such an early stage will be helpful when they later begins to make sounds into words. They can actually show signs of recognition of words they heard. This very early exposure to language offers an advantage when children enter school. It is even believed that during gestation, a baby can distinguish between different languages. Babies benefit when both parents and other family members speak to them while in the womb. Reading to your baby, singing songs, and listening to music can all be stimulating to development.

ʟOVE ʙUILDS MY BRAIN

COMMUNICATING WITHOUT WORDS

It is ironic that during the first three years of life, the time in which 90 percent of a baby's brain develops, we must rely mostly on nonverbal means of communication. In light of the fact that everyday interactions between parents and children shape the brain, the importance of developing our capacities for nonverbal communication seems paramount. Enhancing our capacity to read and respond sensitively to babies' cues, to engage with them in eye contact, to wonder what their behavior might mean, and to respond to them with emotional sensitivity will help them develop language capacities as well as social, emotional, and cognitive abilities. The more we can enter into the back-and-forth dance with them, the more we can help wire their brains in an optimal fashion.

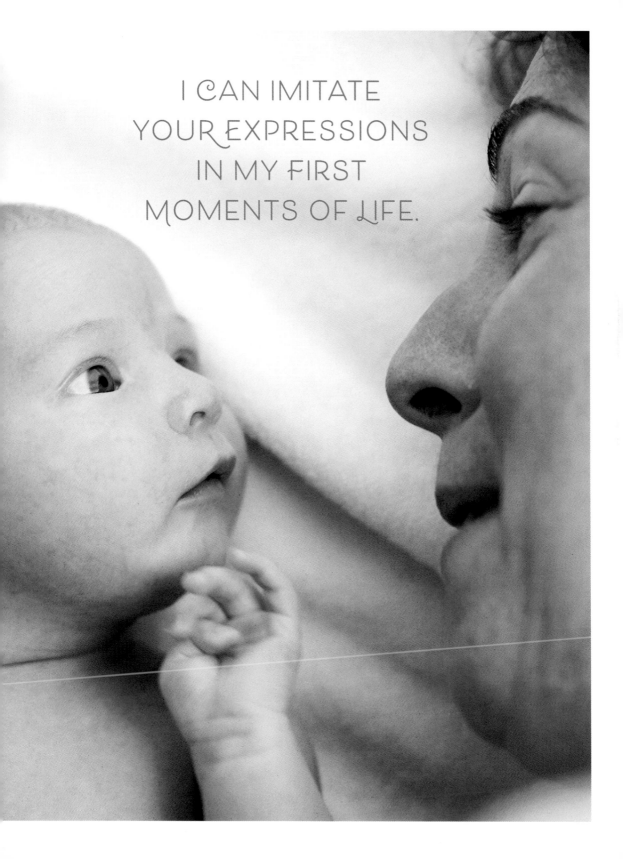

I CAN IMITATE
YOUR EXPRESSIONS
IN MY FIRST
MOMENTS OF LIFE.

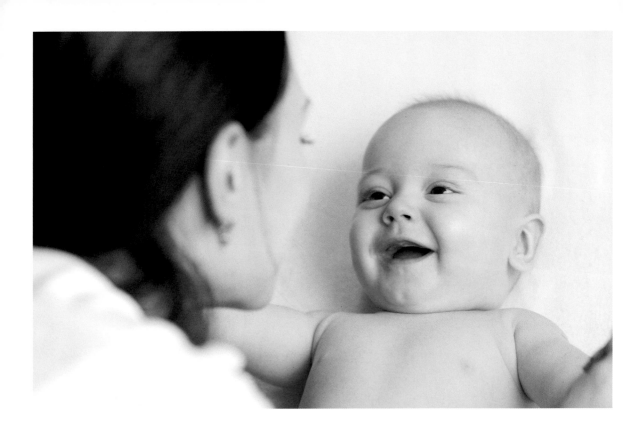

I LEARN WHO I AM AND WHO I CAN BECOME THROUGH MY INTERACTIONS WITH YOU.

EYE-TO-EYE

Early learning takes place through relationship and interaction. When you talk to your baby, soothe your baby, look at your baby, hold or rock your baby, you are helping her feel emotionally secure, and you are helping to stimulate the growth of her brain. Research has even shown that making eye-to-eye contact with your infant stimulates the part of the brain that is responsible for moral and social development.

Warm, sensitive, responsive parenting provides a blueprint for children's forming healthy relationships throughout life and increases the chances for positive life outcomes. So don't hold back: Be as loving as you can be. Your responsiveness is part of nature's brilliant plan to ensure the optimal development of your baby.

We truly are our children's mirrors and models. Ordinary acts of caregiving can have an extraordinary impact on a child's development. Babies' minds grow when they feel connected to their caregivers. The more nurturing we are to ourselves, the more present we can be and the more of ourselves we can give to the children in our care.

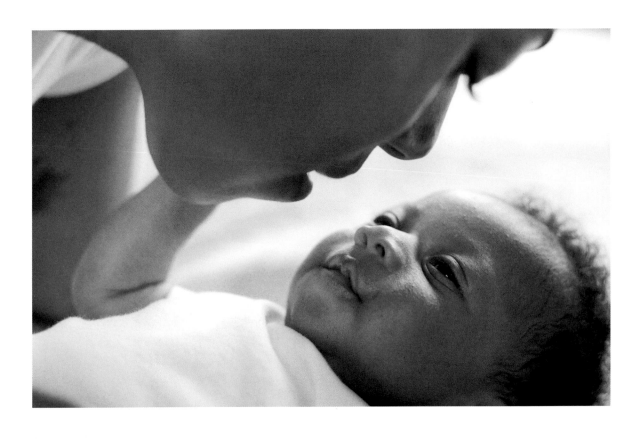

YOUR FACE IS MY MIRROR.
I CAN SEE MYSELF
IN YOUR REFLECTION.

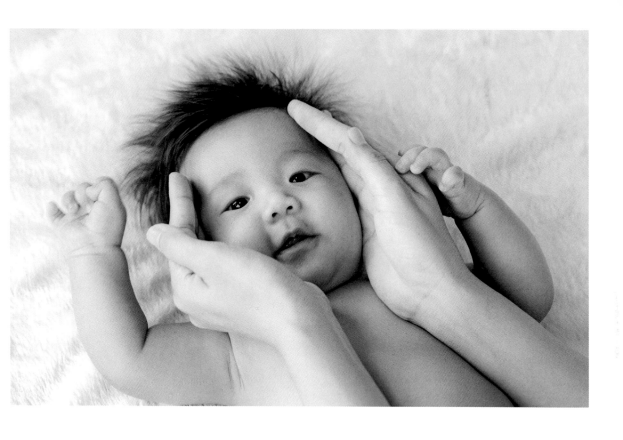

YOUR TOUCH IS
LIKE MAGIC!

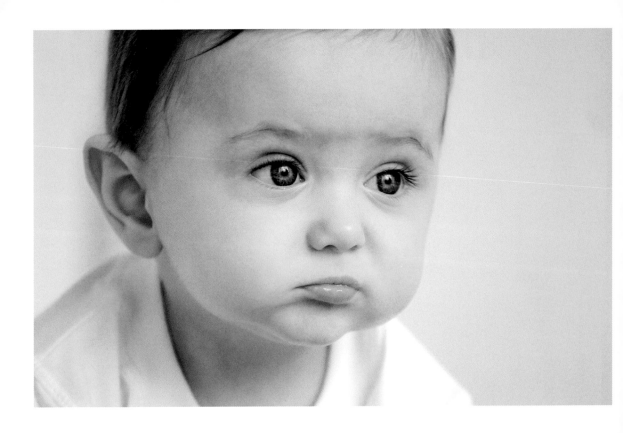

I AM VERY
SENSITIVE AND
AWARE.

YOUR EMOTIONS AFFECT ME

Researchers have found that newborns and infants experience feelings of sadness, fear, and anger as early as the first months of life. They are also affected by their parents' feelings. A study by the national organization Zero to Three found that most parents are not aware of the impact that their emotions have on their children, or how much their children are already capable of feeling. The study also found that infants' emotional well-being can be affected by the emotions expressed by their parents.

YOUR SOCIAL NEWBORN
I HEAR YOU!

Babies begin life with the ability to show kindness and caring toward others. They are born with the capacity to be empathetic and demonstrate significant sensitivity to the emotions of others. Immediately after birth, newborns show concern and become distressed when they hear other babies cry. As a result, they may even cry themselves.

It is often believed that empathy isn't developed until preschool, but it has been shown that babies demonstrate empathy even before they can speak.

Newborns demonstrate preferences even before birth. Scans of the womb have shown babies smiling when classical music is played and frowning when more raucous music is played. When born, they recognize music that was played frequently during the last trimester of pregnancy and also show signs of recognition of words that they heard while in the womb.

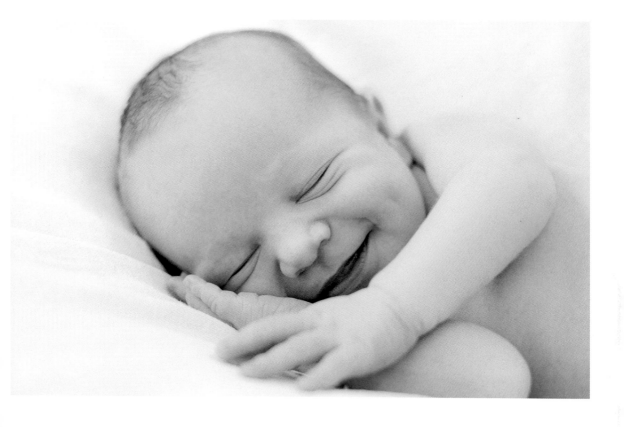

I FEEL YOU!

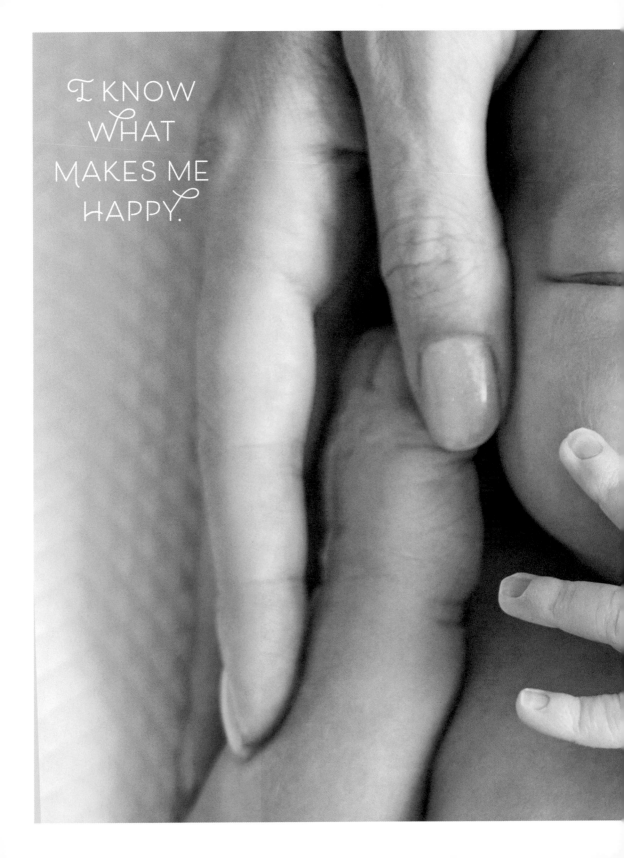

I KNOW
WHAT
MAKES ME
HAPPY.

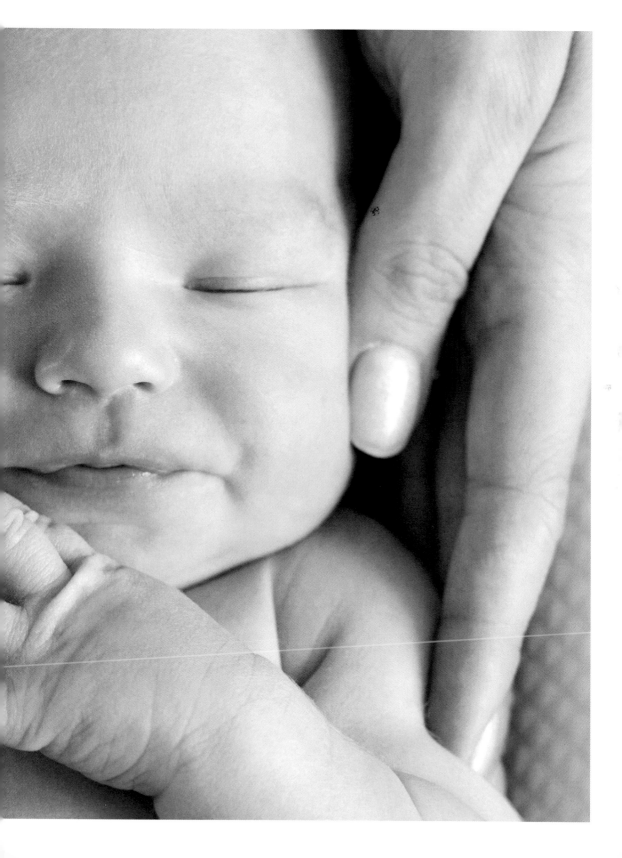

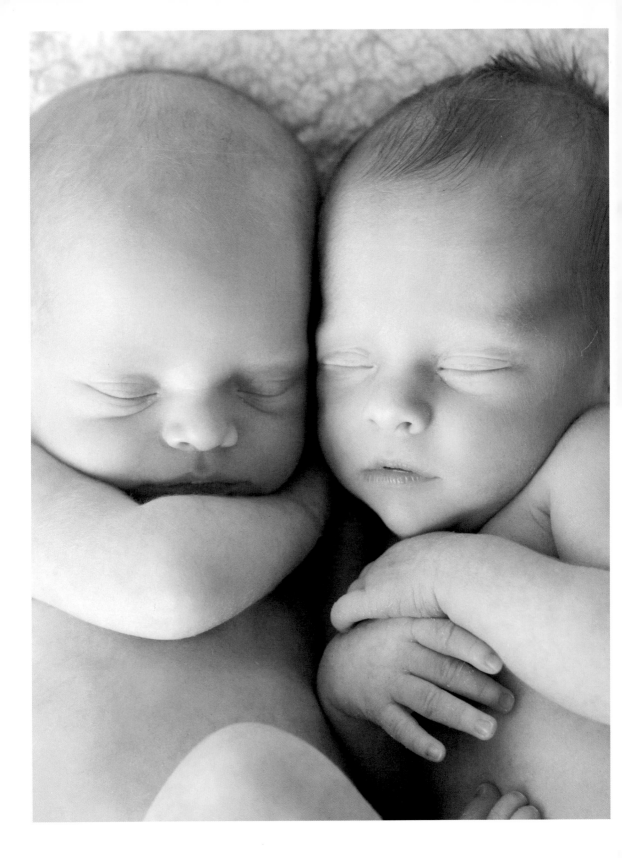

SOCIAL FROM THE START

Social interactions start early! Twin fetuses have been seen on scans reaching out and connecting with one another as early as 14 weeks of gestation. Over time, they have been found to connect with one another with increasing frequency. Their interactions, which include stroking one another's head or back, are thought to be intentional. The way they connect has led researchers to conclude that the development of a sense of self and of others begins in the womb.

WE ARE DRAWN TO
EACH OTHER FROM
THE BEGINNING.

SWEET SLEEP, DEEP SLEEP

A baby's brain creates a range of chemicals and hormones. When we create a calm atmosphere and a soothing routine, chemicals that can help a baby fall asleep are released. Peaceful routines stimulate the release of the sleep hormone, melatonin, as well as the calming chemical oxytocin. When a parent is in a calm state of mind, the baby can achieve a relaxed state more easily. Regularly experiencing this calm state can lead to babies eventually releasing melatonin and oxytocin on their own.

WHEN YOU ARE CALM, I FALL ASLEEP MORE EASILY

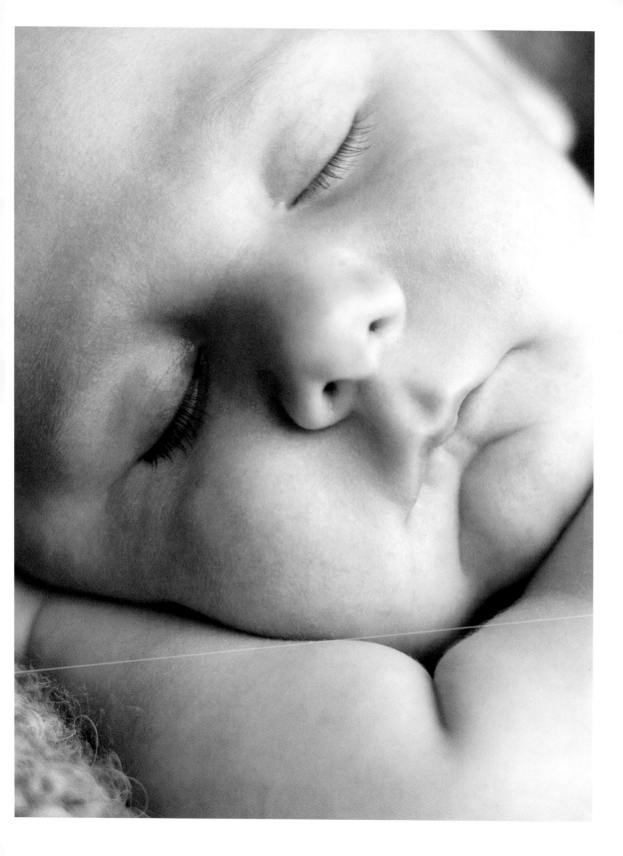

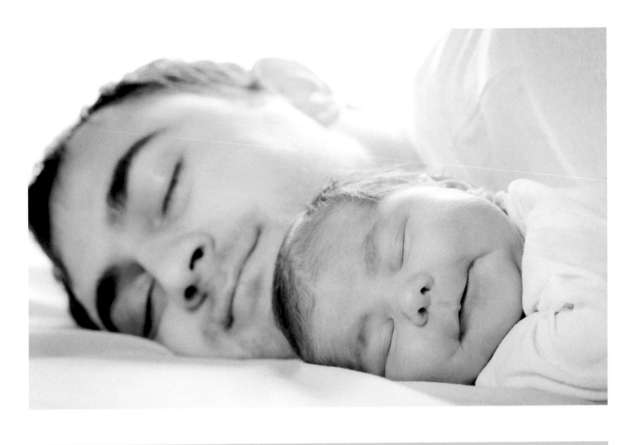

HOME SWEET HOME

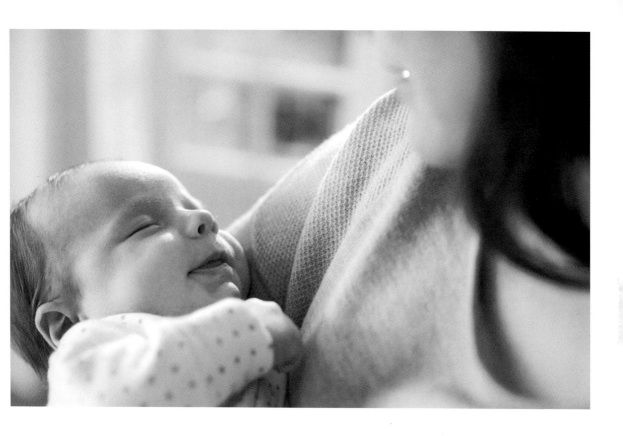

MY FAVORITE SPOT!

SKIN-TO-SKIN:
THE POWER OF TOUCH

Touching your newborn is one of the most beneficial things that you can do. Skin-to-skin contact, specifically chest-to-chest contact, is referred to as "kangaroo care" because it resembles the way marsupials carry their young in their pouches. The term was coined in the 1970s when doctors in a Colombian hospital ran out of incubators and were forced to place premature babies directly on their mothers' chests. The babies flourished!

Even small doses of direct contact with your baby help them breathe more easily and regulate their heartbeat and body temperature, which ultimately improves their health. Higher blood oxygen levels are also attained. Skin-to-skin contact enhances a child's brain development, and as little as twenty minutes of touch has been shown to drastically lower stress hormones in babies, making them less likely to cry.

The many benefits of touching are long lasting: Touch facilitates digestion and nutrient absorption and helps build stronger immune systems. The interaction also allows babies to form healthy sleeping patterns and helps them better manage pain. The contact even allows a baby's skin to help create a barrier to harmful bacteria. Babies who are held are also shown to socialize more in the first years of their lives.

In addition, newborns who experience frequent skin-to-skin contact have more successful breastfeeding experiences, which helps them maintain healthy weight gain. Babies who have contact immediately after birth are twice as likely to breastfeed within the first hour. This closeness also helps stimulate the production of the mother's milk.

The health benefits of touch aren't just limited to babies. Mothers who practice skin-to-skin interactions are less likely to develop postpartum depression, experience less anxiety, and can better relate to their child. Fathers benefit too; by holding their child bare chest to bare chest, fathers create intimacy and can experience the pleasure of bonding.

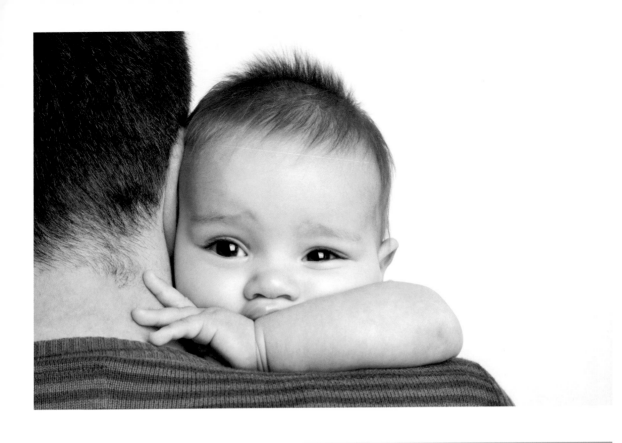

I NEED TO BE
NEAR YOU.

BUILDING TRUST

Learning to trust is one of the main developmental tasks of the first year of life. When a baby learns to trust during this period, his or her brain will be primed to trust throughout life. Trust develops when a baby can count on needs being met, knows that a parent is emotionally available, and has soothing routines. Responsive, sensitive parenting gives a baby's brain the message that the world is a safe place and that people are dependable. If we don't learn to trust in the first year of life, it is harder to do so later on. When we are receptive and responsive to babies, they become wired to expect these kinds of responses from others throughout life.

ONE WORLD, ONE HEART

Touching and holding babies have numerous benefits. This contact stimulates connections in their brain, lowers stress hormones, reduces crying, strengthens the immune system, increases bonding, and lessens the impact of pain. It is interesting to note that babies who are held often and are securely attached to their parents in the first six months of life do not show elevated levels of cortisol, the stress hormone, in subsequent stressful situations.

Too much stress can have a negative impact on a baby's brain. A nurturing relationship protects children from the impact of stress and helps them manage challenges throughout life.

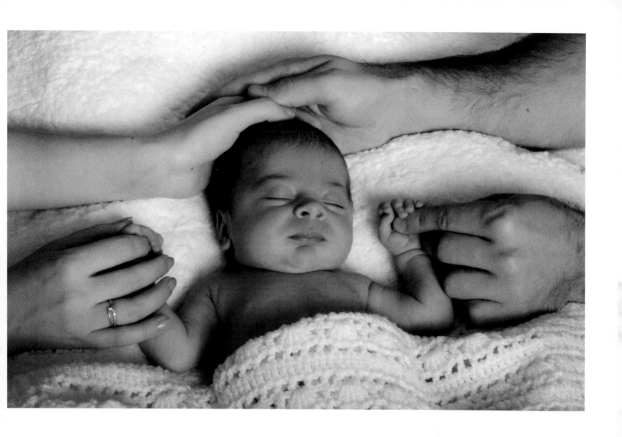

WHEN I AM CONNECTED
WITH YOU, I CAN CONNECT
WITH THE WORLD.

LOVE FOSTERS LATER RELATIONSHIPS

The nature of a baby's attachment to her parents has been found to have a profound and lasting impact on how she will love throughout her life. The mother-child relationship specifically has been studied and found to shape the patterns and outcomes of a child's relationships. For example, infants who have a secure attachment to their mothers are more likely to have successful romantic relationships in early adulthood.

Securely attached infants have also been found to more easily resolve and recover from relationship conflicts and to enjoy stable, satisfying ties with their partners later in life. Children who grow up with warmth and develop a sense of well-being tend to feel lovable and recognize their ability to bring joy to others.

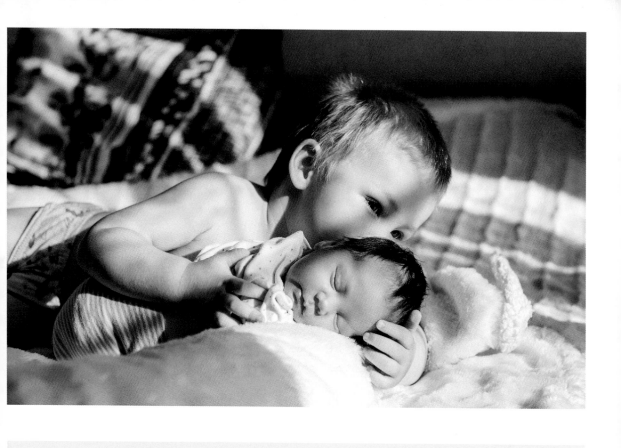

THE WAY YOU LOVE ME
SHAPES HOW I WILL LOVE
MYSELF AND OTHERS.

· 2 ·

LOVING INFANTS

There are more than a thousand studies that demonstrate the positive impact of loving interactions on a baby's brain. Smiles, hugs, and other nurturing interactions in the first years of life help children concentrate, think more clearly, set and achieve goals, and form healthy relationships.

Infants begin to develop a sense of who they are and who they can become through their interactions with their parents and other significant adults in their lives. Research now tells us that the single most important factor in shaping a child's future is the quality of their attachment to a parent. Children who have secure attachments with their parents have been found to have more positive outcomes in a range of areas, including personality development, learning, and the ability to form healthy relationships.

Secure attachments are formed when a parent and infant enter into a reciprocal, mutual dance, one where the parent is emotionally available, responsive, and sensitive to the baby's cues and helps to meet her needs. This attuned connection is thought to be the foundation for building self-confidence, curiosity, independence, cooperation,

and trust, as well as the ability to make friends and get along well with others.

There is a growing awareness of the profound and lasting benefits of nurturing interactions on every area of a baby's development during the first years of life. Warm, sensitive responses have been found to increase a baby's immune system and lead to better health in middle age. Strong maternal bonds can protect babies' developing brains and health from the adverse impact of poverty and other stressful conditions. Hugs have been found to lessen the negative impact of a challenging childhood. They can also protect a child's heart from the impact of stress and lower their blood pressure. Emotionally sensitive responses can release hormones that give babies feelings of joy, compassion, empathy, generosity, and concern for others.

Parental warmth and affection have been found to help babies develop psychological strength and protect them from feelings of loneliness, isolation, and anger. Research shows that sensitive, loving interactions help children think under stress, become socially confident, turn difficult situations into opportunities and be able to reflect on themselves and their own behavior. Nurturing interactions wire babies for emotional health and foster the likelihood of success in all areas of life.

Comforting responses from adults also help babies develop the capacity to soothe and calm themselves. This capacity is considered to be a cornerstone for emotional, social, and cognitive development, impacting such areas as concentration, attention, and the understanding of oneself and others.

When infants do not experience safe, predictable responses, it is hard for them to feel that the world is safe. It is through understanding and responding to infants' cues that optimal brain functioning is created.

Newborns and infants come to understand themselves, others, and the world based on their first experiences. When babies' needs are met, when parents respond sensitively and consistently, and when babies experience warm, nurturing, attuned interactions, they begin to develop a positive sense of themselves and establish feelings of worthiness, confidence, and their ability to have an impact. T. Berry Brazelton, one of the foremost American pediatricians, felt that by the age of eight months, infants already have an internal sense of their capacity to be effective.

THE PROFOUND IMPACT OF SIMPLE INTERACTIONS

The past decade has brought out an exciting new understanding of how children's minds work and develop. Classic theories about the importance of the first years of life have been validated by scientific data. While professionals in the early childhood fields have long recognized how much infants and babies know and are capable of learning, this knowledge is becoming more widely recognized.

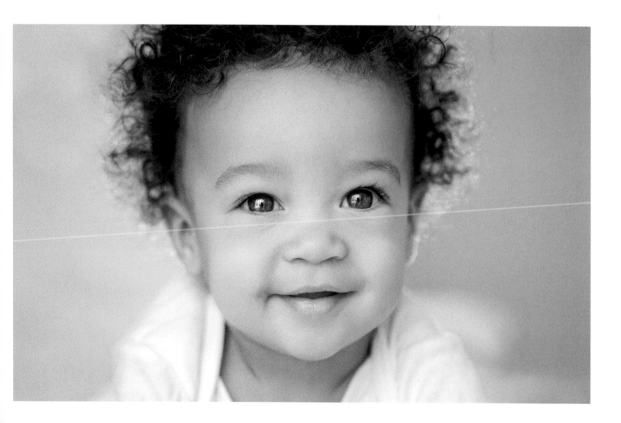

YOUR LOVE
HELPS MY BRAIN
GROW LARGER!

Perhaps what is most exciting about this research is that it confirms that relationships, along with experience, are the foundation for healthy emotional, social, and cognitive development. The data tell us that the small, moment-to-moment interactions with babies and young children help shape their sense of self and impact who they become. The simple things that occur in the everyday dance between babies and their parents do the complex work of wiring the neural pathways in their brains. Our daily responses to them impact how they see the world and their role in it.

When we read and respond sensitively to a baby's cues, for example, we are fostering brain development. Matching their level of excitement or lessening stimulation when they seem overwhelmed promotes healthy brain wiring. Simple eye-to-eye contact helps babies become more aware of themselves. It also stimulates the part of the brain that is involved in moral development, thereby helping babies to become more sensitive to others.

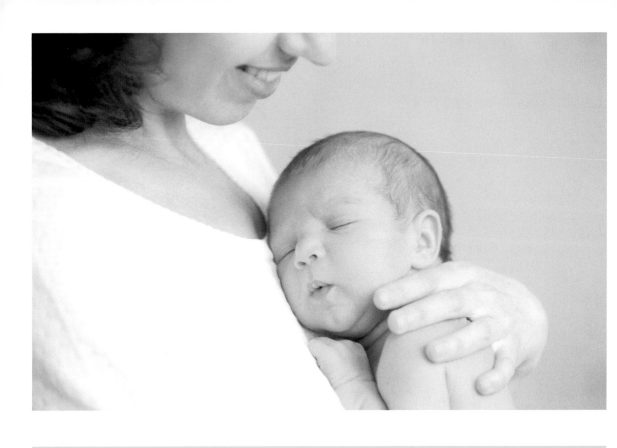

THE LOVE YOU GIVE
TO ME I WILL BE ABLE TO
GIVE TO OTHERS.

THE POWER OF LOVE

Loving relationships can have a significant impact on a child's brain size. A groundbreaking study found that the hippocampus, the part of the brain responsible for learning, memory, and managing stress, was almost 10 percent larger in school-age children whose mothers were nurturing and supportive than in children whose mothers were not as nurturing.

The study also found that increasing parental warmth could greatly *reduce or even eliminate the negative impact of poverty and other stressful conditions on a developing brain.*

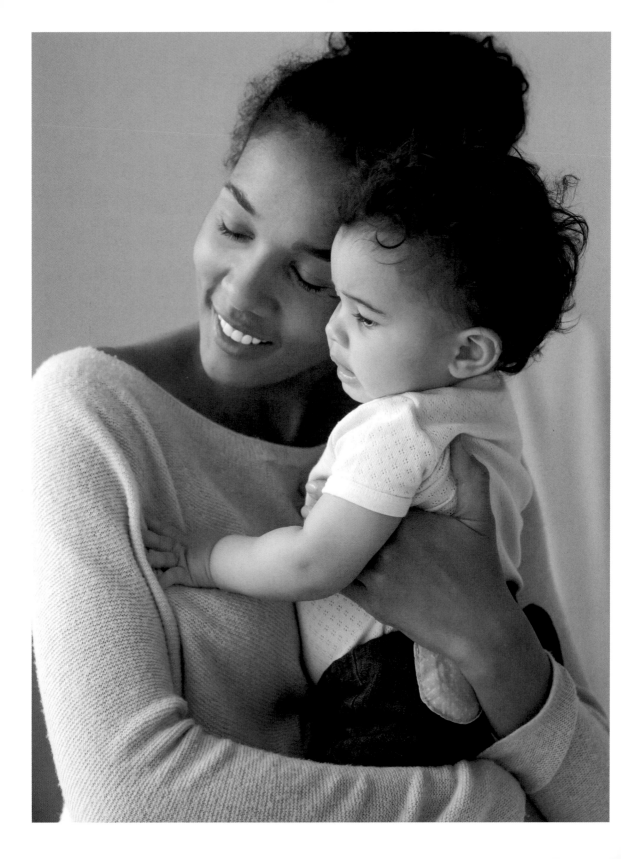

YOUR LOVE AND
ATTENTION NOW WILL
HELP ME STAY HEALTHY
AS I GROW.

THE HUGS YOU
GIVE ME WILL HELP
ME STAY CALM
THROUGHOUT MY
LIFE.

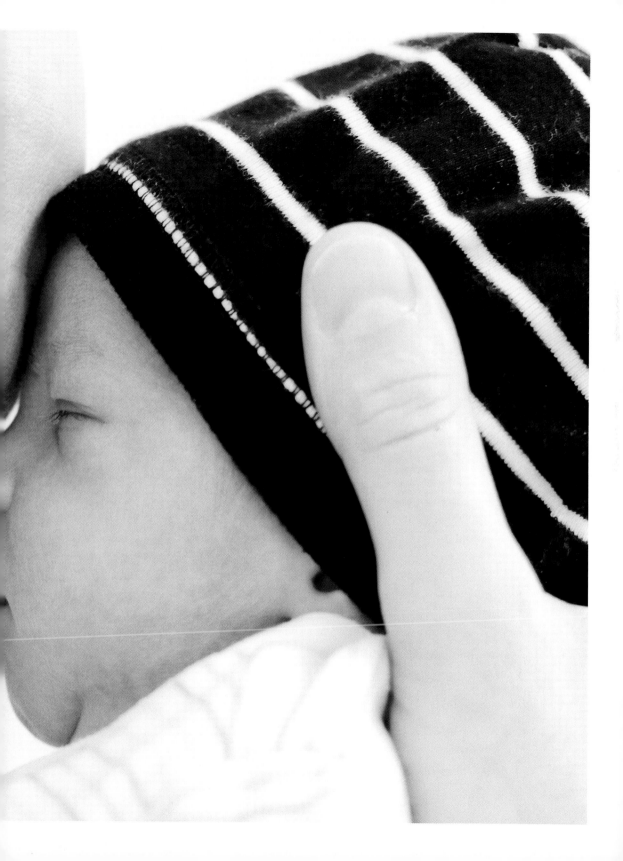

YOUR KINDNESS WILL
HELP ME GROW UP WITH
A SENSE OF PEACE AND
WELL-BEING.

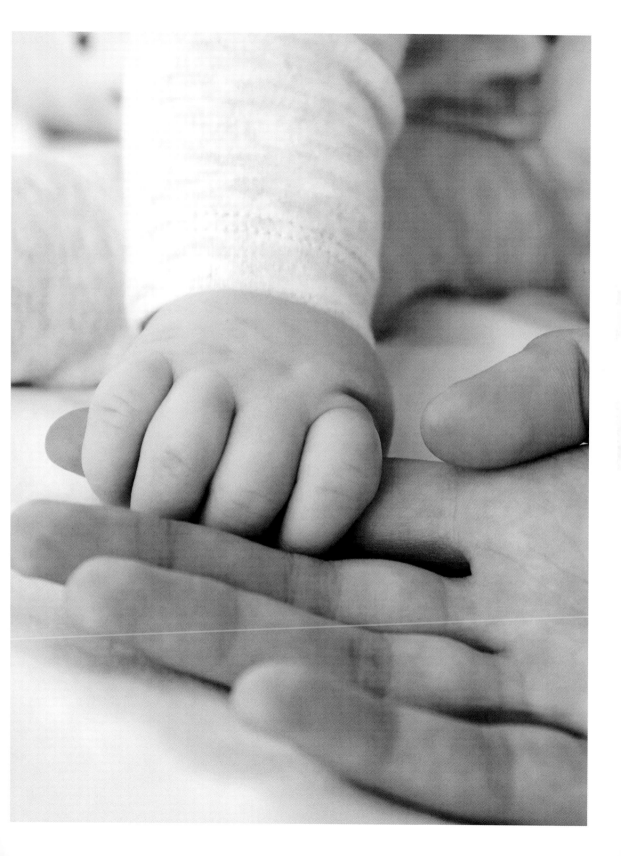

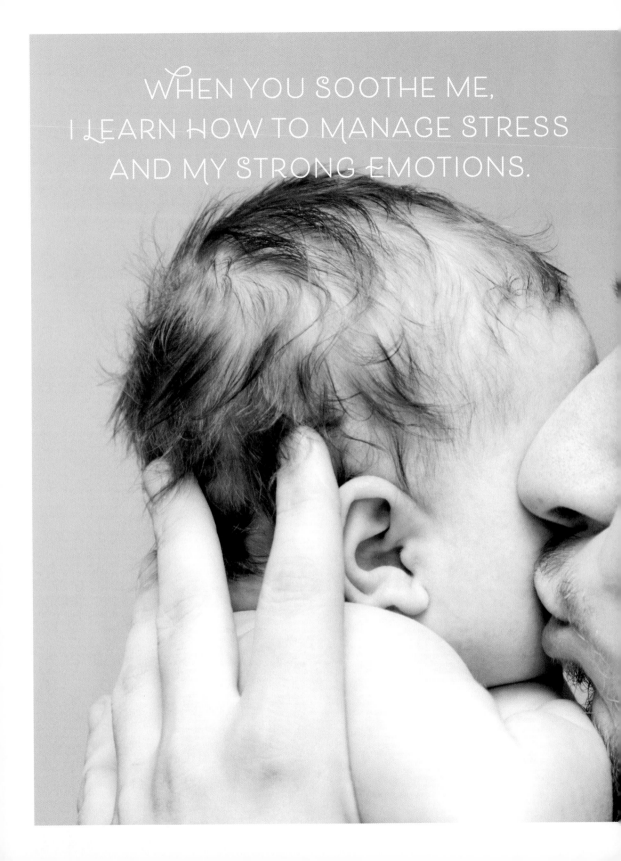

WHEN YOU SOOTHE ME,
I LEARN HOW TO MANAGE STRESS
AND MY STRONG EMOTIONS.

HEAR MY CRY

Responding to babies' cries and meeting their needs in infancy wires them to be able to soothe themselves and teaches them that their actions can have an impact. Responsiveness to babies actually fosters feelings of competence, independence, and trust. The *more* we meet babies' needs, the *less* needy they become.

WHEN YOU RESPOND
TO MY CRIES, I LEARN
THAT I AM IMPORTANT,
THAT MY FEELINGS
MATTER, AND THAT MY
NEEDS CAN BE MET.

YOU CAN'T SPOIL ME

We are often afraid that if we respond to our babies' needs, we will spoil them and encourage their dependence on us. Actually, the prevailing research demonstrates that when an infant expresses a need and an adult responds with sensitivity and warmth, the seeds of trust, security, and confidence are planted. The more secure a baby feels, the more confident she becomes about exploring the world on her own. When we meet the needs of an infant, we are encouraging her to initiate activities by demonstrating that her actions will have an impact and will bring about desired results. Of course, encouraging babies to do things for themselves once they have the capacities to do so promotes healthy development and teaches important lessons.

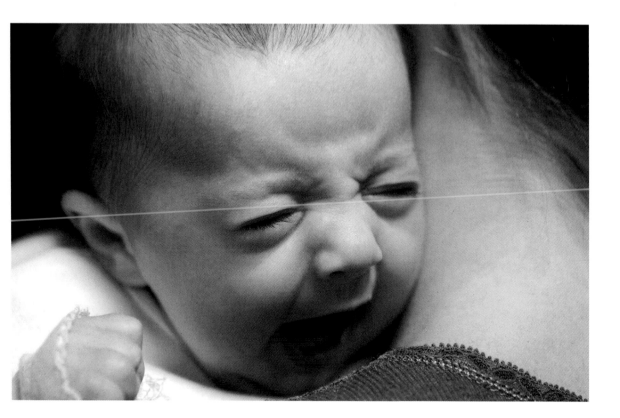

When an infant is not sure that her needs will be met, she can be distracted by tension and anxiety, limiting her ability to engage in new activities or developmental tasks. Our lack of an attuned response can discourage a child and leave her feeling more dependent and less secure. Encouraging a child to do things for herself as she becomes increasingly able can foster her growth, but it is important to keep her capacities in mind so as not to cause excess frustration. When we are aware of what she can and cannot yet do, it can guide our expectations and interactions. It is important to build upon developmental capacities.

When we don't respond to infants' cries and leave them to manage their stress on their own, we can establish the foundation for the inability to manage stress throughout their lives. Researchers have confirmed that leaving babies to cry for prolonged periods can have a long-lasting negative impact on their developing brains.

The old approach to let a baby cry it out and the belief that picking babies up when they cry will spoil them have been put under new scrutiny. Stress releases cortisol into the system, which has been shown to interfere with cognitive development. Stress activates the primitive part of the brain and leads to a fight-or-flight response. In this condition, learning cannot take place. Soothing responses help the brain return to higher functioning. There is evidence that responding to a baby's cries in the first sixty seconds can avoid an escalation that can be hard to alleviate.

When babies are stressed and not comforted, cortisol can continue to be released into their system and can negatively impact their brain wiring. When we don't soothe babies, they can become wired to release cortisol and other stress hormones more often throughout life, rather than being flooded with positive hormones such as serotonin and oxytocin, which lead to feelings of joy, well-being, and calm. Too much exposure to cortisol and other stress hormones can weaken the immune system and lead to health challenges.

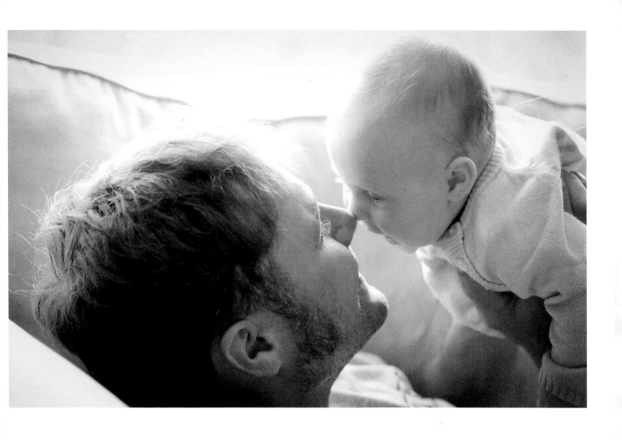

YOUR LOVE BUILDS
MY CONFIDENCE AND
MY SELF-ESTEEM.

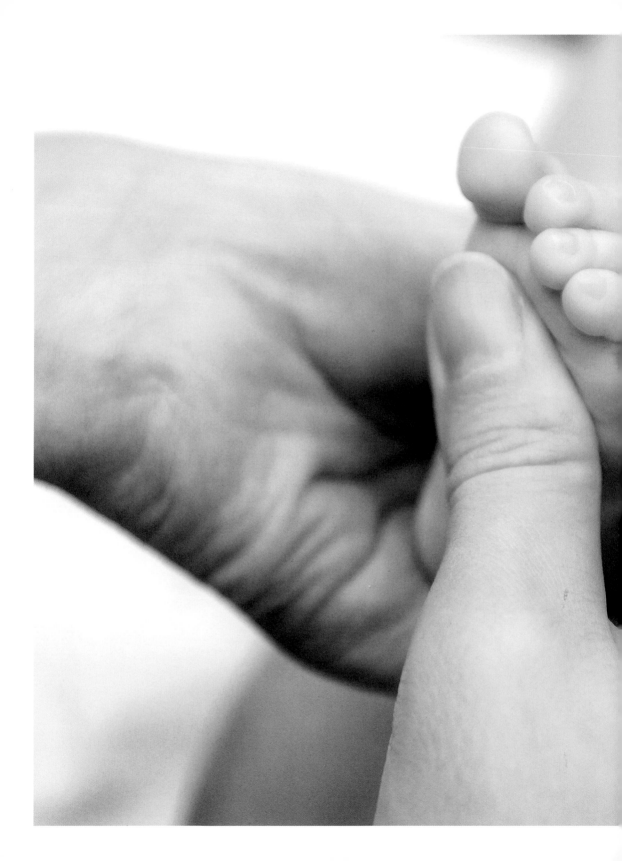

YOUR TOUCH
BUILDS MY
IMMUNE SYSTEM.

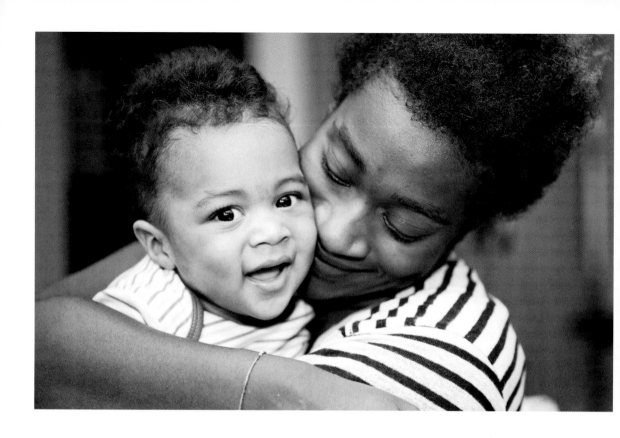

YOUR HUGS MELT
MY FEAR.

SIMPLE SOOTHING

Holding and soothing babies activates the largest nerve in the body, the vagus nerve, which regulates all the major organs.

When the vagus nerve is activated, the nervous system and breathing rate slow down, the digestive system and heart rate are rebalanced, and clearer thinking, better emotional balance, and improved powers of attention are achieved.

Nurturing interactions stimulate the production of "happy hormones" that help babies manage stress and experience feelings of well-being, joy, peacefulness, and empathy throughout life. When we do not comfort babies, they may not develop the ability to handle challenges or difficult feelings.

TAKE ME IN YOUR ARMS

Close physical contact is one of the most effective ways to help babies feel calm and secure and to experience the world as warm and welcoming. Being held releases hormones that help babies feel good about themselves and develop a positive outlook throughout life. Being held fosters a secure attachment, which has been recognized as a critical factor in children's emotional and social well-being and as a protection against social-emotional problems later in life.

BEING IN YOUR ARMS NOW WILL HELP ME FEEL SAFE, SECURE, AND STABLE THROUGHOUT MY LIFE.

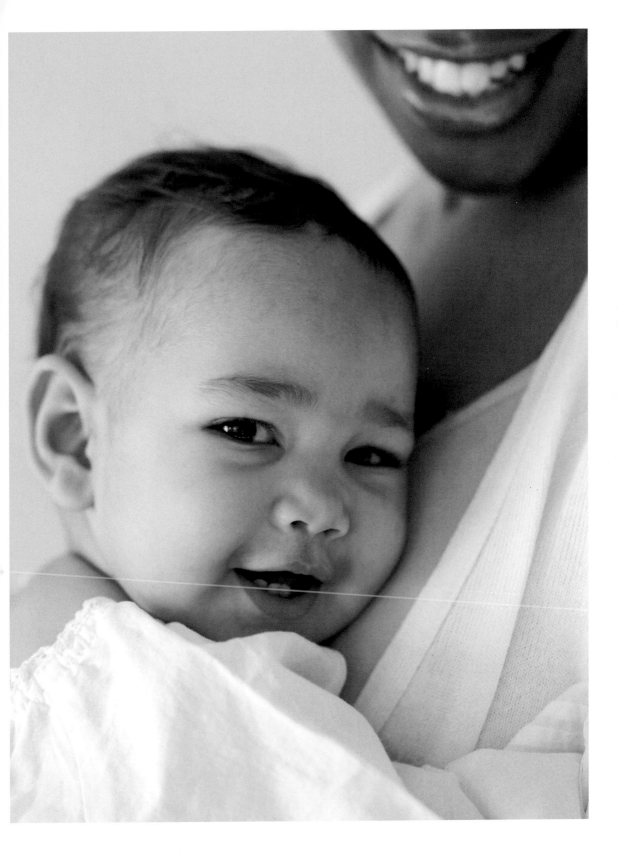

YOUR CUDDLES FILL
ME WITH A SENSE
OF HAPPINESS AND
WELL-BEING.

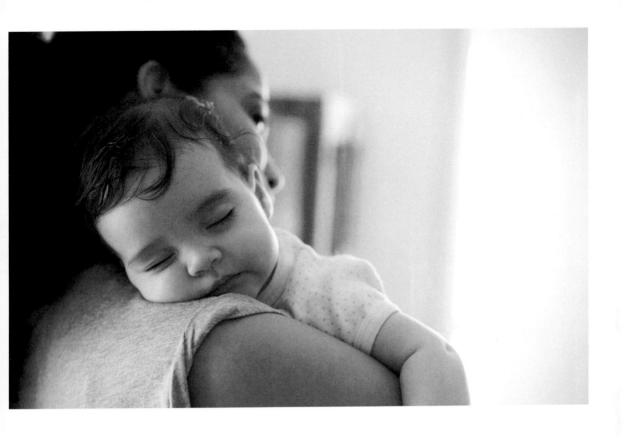

YOUR TOUCH WIRES ME
WITH FEELINGS OF KINDNESS
AND GENEROSITY.

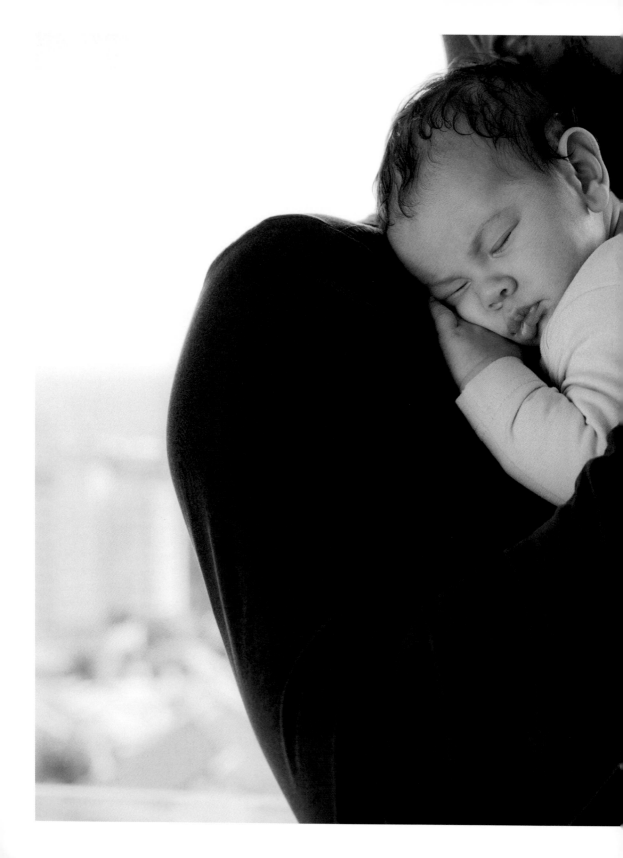

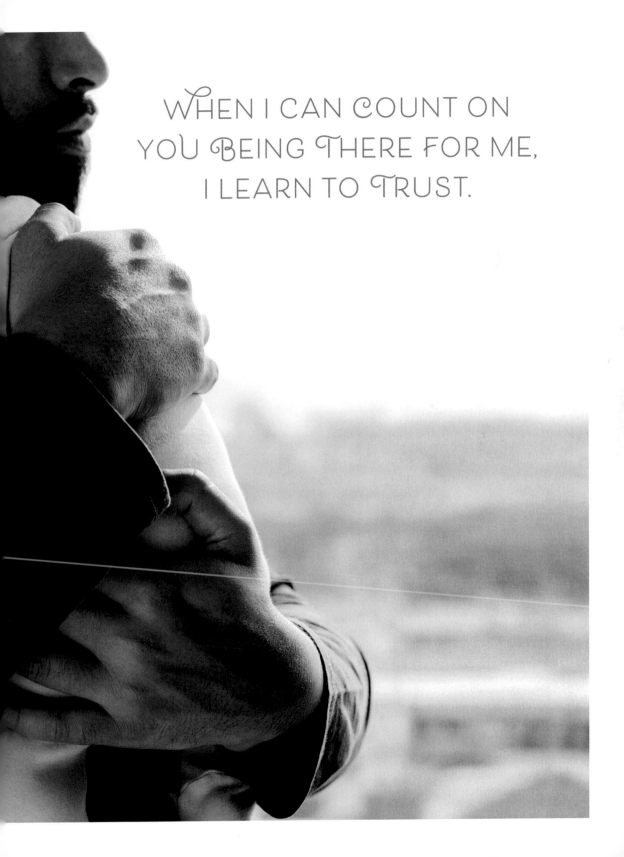

WHEN I CAN COUNT ON
YOU BEING THERE FOR ME,
I LEARN TO TRUST.

YOUR WARM TOUCH
BUILDS MY BRAIN AND
MY SELF-ESTEEM!

THE LIGHT OF YOUR SMILE

A parent's smile is thought to be the most important stimulus to the growth of the emotionally intelligent brain. It triggers the release of hormones that stimulate neuronal connections and the growth of a baby's higher brain. The higher brain controls executive functions, decision making, planning, judgment, and reasoning. Positive expressions enhance bonding and attachment and foster feelings of joy, calm, warmth, and well-being. Smiles also help children feel lovable and recognize their ability to bring joy to others.

Smiles during the first years of life can impact children's ability to empathize with others as well as to regulate their emotions. Smiles also help babies feel safe, secure, and more social, enhancing their ability to form loving relationships.

A parent's expression affects a child's behavior in different environments. Infants and toddlers look to their parents' expressions for guidance with regard to their activities and behavior. They read smiles as encouraging and frowns as discouraging.

Face-to-face interactions release hormones that stimulate positive feelings in both parents and newborns and deepen the bond between them. Eye contact triggers neural pathways that prepare babies for communication, helping them read and respond sensitively to others' cues and begin to better understand the world. Scientists have found that when mothers and babies make eye contact, their brain waves become synchronized, and babies tend to make more of an effort to communicate. This has also been found to be an indicator of greater vocabulary skills later on.

Babies are talking to us all the time. When we respond to their "ohs" and "ahs," we are helping them establish patterns of communication, increasing their sense of self, and fostering a connection. When we soothe and comfort them, we are teaching them how to soothe and comfort themselves. Simply smiling at a baby or child can encourage them to explore their world. In an experiment that was designed so that it appeared as if there was not a surface to climb across, babies whose caregivers smiled at them "took the risk" and crawled across the "invisible surface." Those babies whose caregivers frowned at them declined from doing so. Our facial responses and tone of voice have a strong impact.

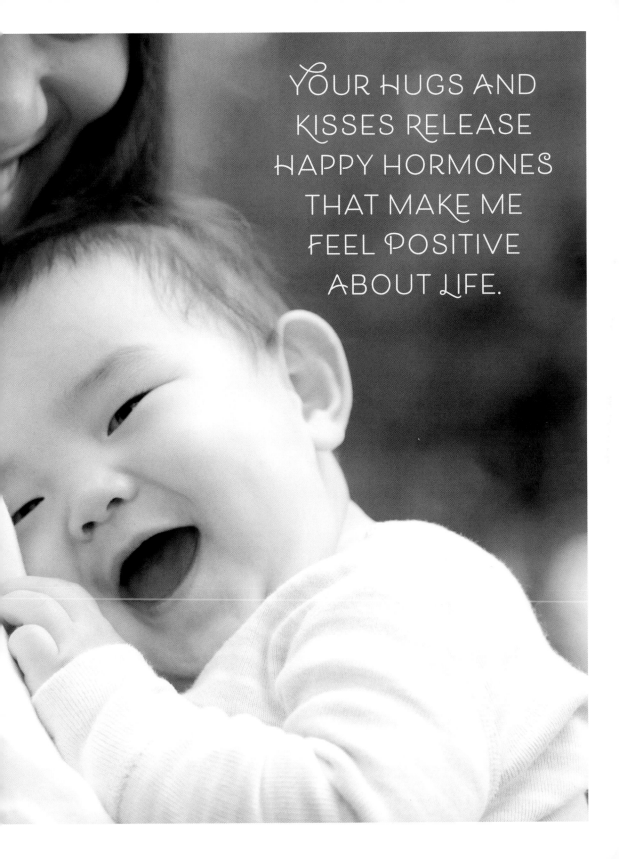

YOUR HUGS AND KISSES RELEASE HAPPY HORMONES THAT MAKE ME FEEL POSITIVE ABOUT LIFE.

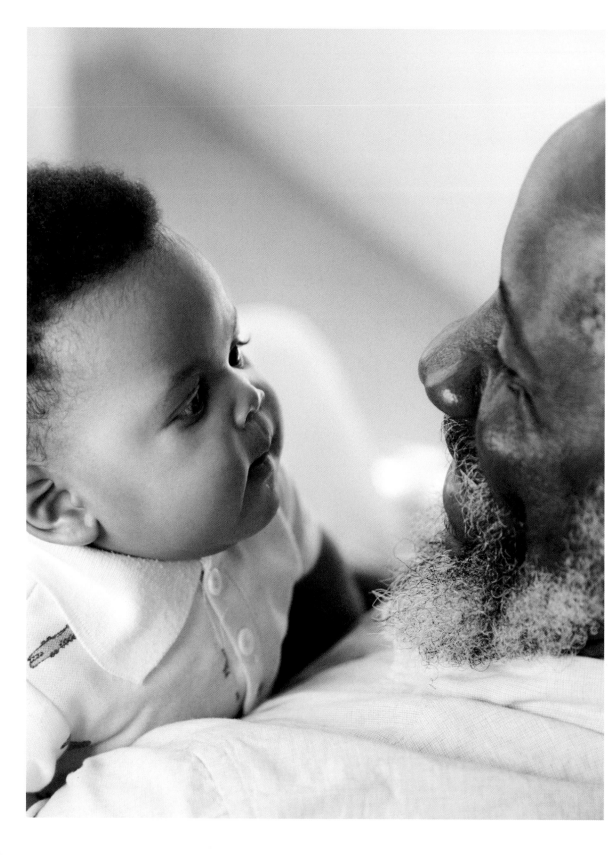

YOUR SMILE
HELPS ME FEEL
THAT ALL IS WELL
IN THE WORLD.

WHEN YOU LOOK
IN MY EYES, YOU HELP
ME LEARN TO RELATE
TO OTHERS.

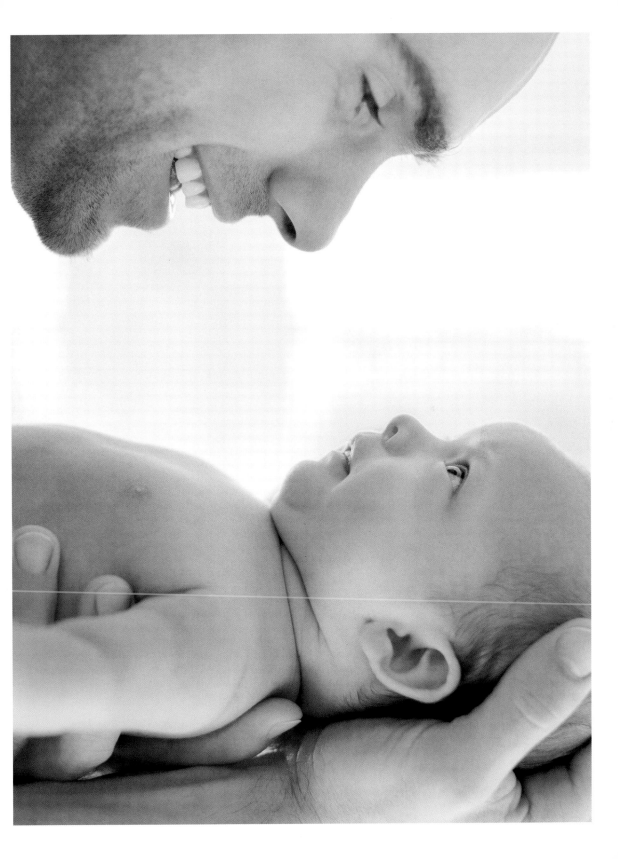

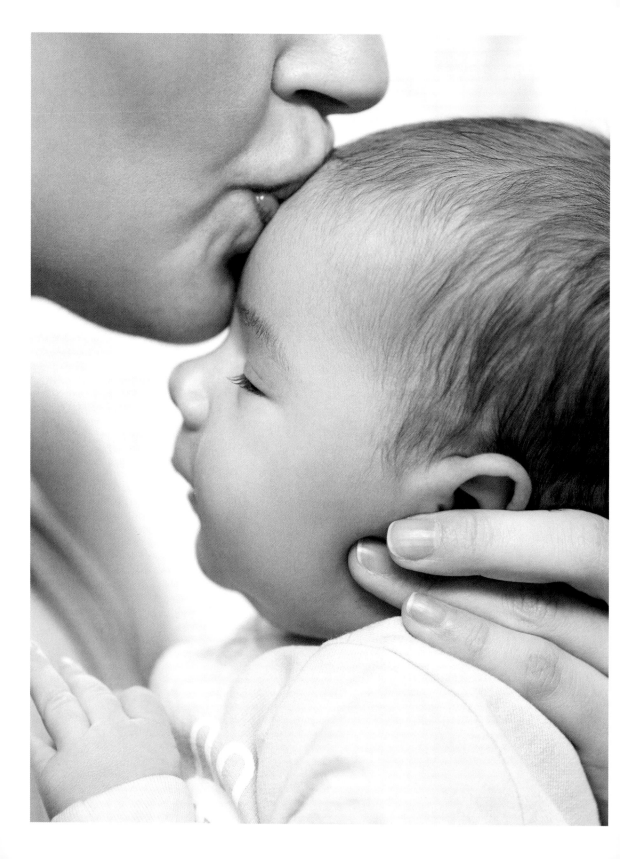

MY MIND
GROWS WHEN
OUR HEARTS ARE
CONNECTED.

FACE-TO-FACE

Sensitive, attuned "conversations" foster positive feelings between parents and babies and enhance the bonds between them.

Nurturing face-to-face interactions also develop a band of nerve tissues known as the corpus callosum, which connect the right and left sides of a baby's brain. The left side of the brain, which is the center for language, enables babies to understand and form speech. The right side of the brain processes difficult emotions. When the two hemispheres are connected, babies can better understand and express their feelings, rather than act out.

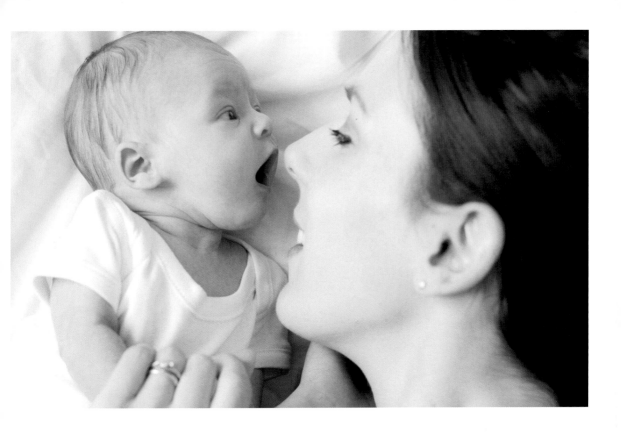

OUR "CONVERSATIONS"
BUILD MY LANGUAGE
SKILLS AND OUR BOND.

THE POWER OF OUR PLAY

Playing with babies in ways that include warm, physical contact fosters positive feelings and bonding. This kind of active play also stimulates higher brain development impacting cognitive functions including concentration and attention, as well as social intelligence. Physical interactive play also helps babies better manage their emotions and stress.

The give-and-take of playing helps babies develop and learn about themselves, the world, and relationships. Babies play in ways that match their developmental level and interest. Babies learn best when adults allow them to be the leader. When we respond to as well as expand on what they are saying or doing, we nurture their competency and sense of self as well as stimulate their development.

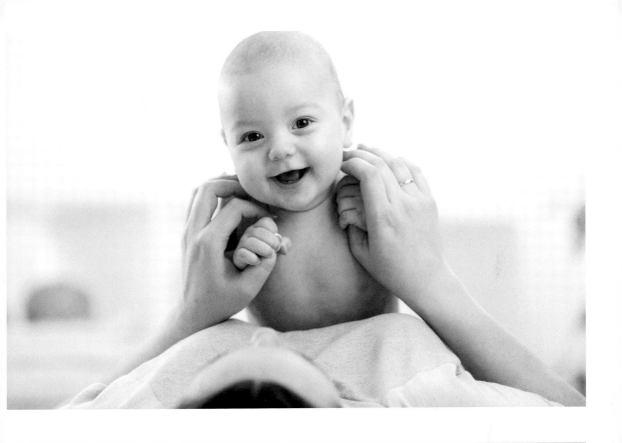

OUR PLAY IS
GOOD FOR MY HEART
AND MY MIND.

THE MAGIC OF MUSIC

Sing with your baby. Dance around the room with music. Clap your hands. Play instruments. Not only will you be bonding in a warm and wonderful way, but you will also be stimulating your baby intellectually. Hearing music has been shown to catalyze the development of pathways in the brain that are responsible for your child's understanding of spatial relationships. Listening to music in the first months of life may help your child excel at math. It may also give her a greater facility for doing puzzles and other activities requiring an understanding of dimension and space. So, from the Beatles to Beethoven, expose your child to a wide range of sounds. The result may surprise you!

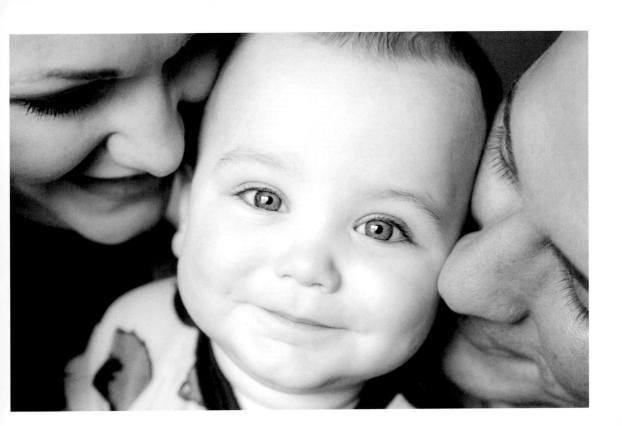

YOUR WARMTH AND
ATTENTION ARE MORE
IMPORTANT TO MY BRAIN
DEVELOPMENT THAN
STRUCTURED LEARNING
ACTIVITIES.

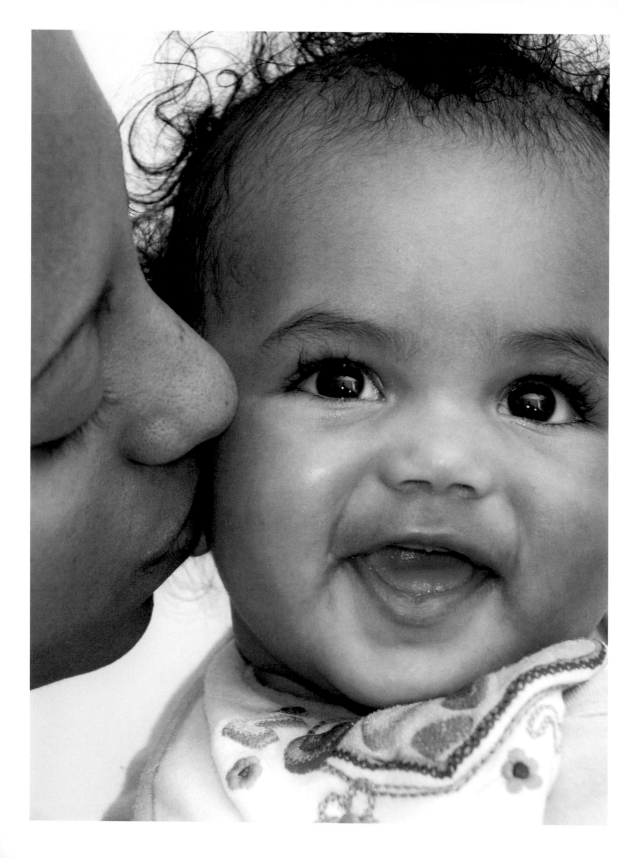

YOUR HUGS AND
KISSES NOW WILL
HELP ME DO WELL
IN SCHOOL.

YOUR NURTURING
RESPONSES HELP
ME CONCENTRATE,
THINK MORE CLEARLY,
REASON, AND
PROBLEM SOLVE.

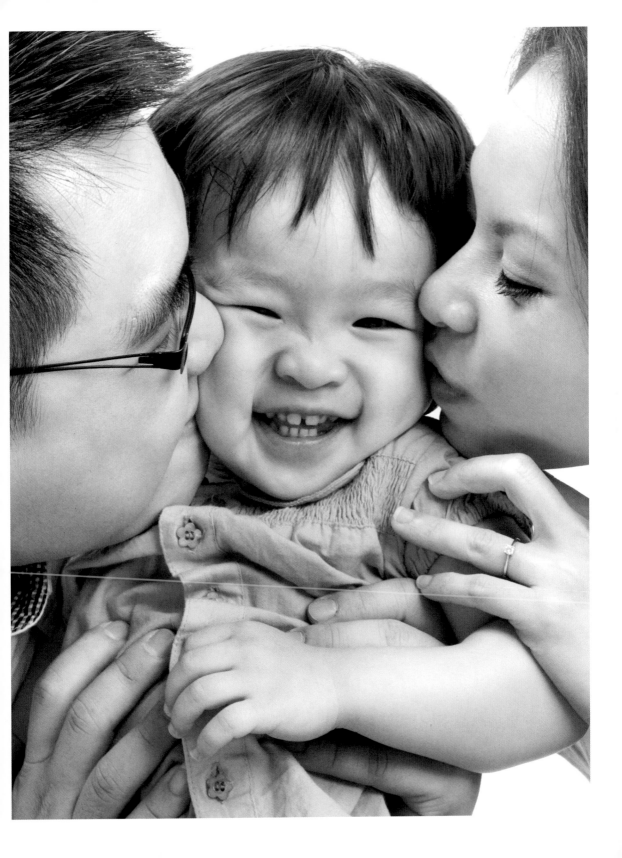

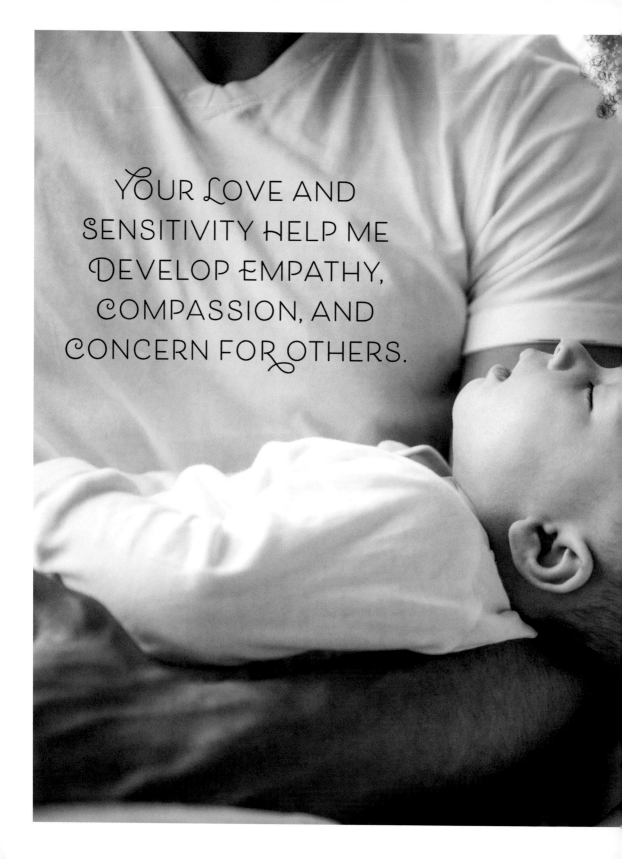

YOUR LOVE AND SENSITIVITY HELP ME DEVELOP EMPATHY, COMPASSION, AND CONCERN FOR OTHERS.

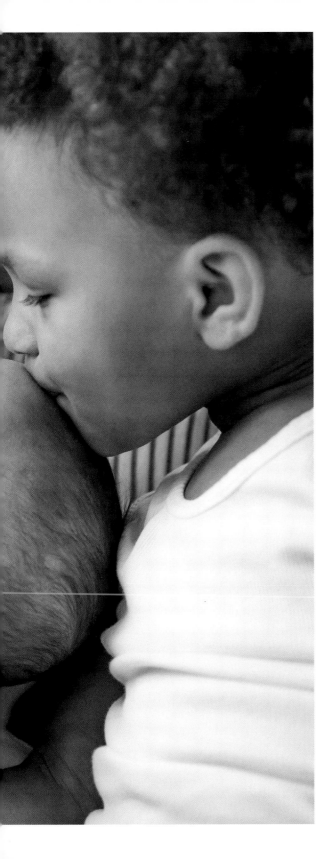

YOUR LOVE LIFTS
ME HIGHER

Warm, emotionally sensitive interactions have been shown to foster confidence, curiosity, self-control, relatedness, and cooperation. These characteristics are recognized by Early Head Start as being more important to school readiness than knowledge of numbers and letters. Consistent, emotionally responsive parenting stimulates the development of the higher brain.

I FEEL YOUR PAIN

Babies will try to help other babies. Studies have shown that if a baby drops a stuffed animal and struggles to pick it up, other babies will help that baby retrieve it.

When babies were left alone with a doll that was rigged to simulate crying, researchers discovered that most of the one- to two-year-olds tried to comfort the doll, even going so far as to offer the "crying" doll a toy. As parents, we can help develop our child's empathy. They look to us for guidance. They observe our emotions and reactions. Babies know when we are happy or sad.

They can tune in to our emotions at a very early age. Babies watch faces early in life and become distressed if we frown or seem upset. Our feelings are contagious to them, and they can automatically absorb them.

Babies show special attention when we speak to them in a pleasant way. They can pick up on our expressions of happiness, sadness, or anger by looking in our eyes. To promote empathy, we need to be emotionally responsive and act as role models for treating others with sensitivity and kindness.

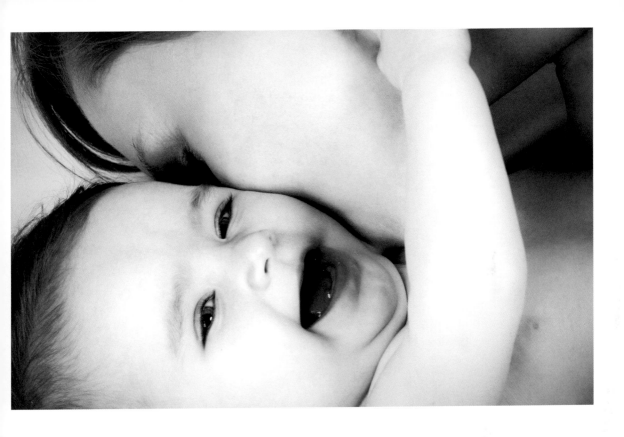

YOUR NURTURING
RESPONSES WIRE ME
FOR HEALTHY, WARM,
LOVING RELATIONSHIPS
THROUGHOUT LIFE.

YOUR LOVE AND AFFECTION INCREASE MY ABILITY TO BOND WITH OTHERS.

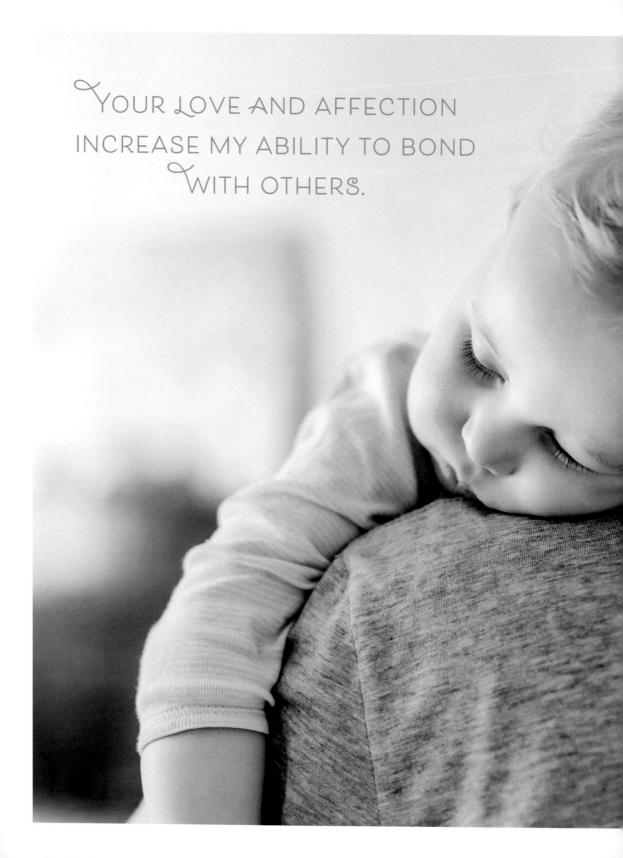

Loving interactions between parents and babies release oxytocin, commonly referred to as the "love hormone." Oxytocin reduces stress and increases trust. Recent research has demonstrated that the sufficient production of oxytocin in infancy is essential to the capacity to maintain healthy interpersonal relationships throughout life.

RETHINKING BABY BOYS

Baby boys have been found to be *more* sensitive than baby girls. The emotional side of boys' brains matures at a slower rate than girls'. Newborn boys have fewer stress-regulating hormones, which leaves them more vulnerable to emotional, environmental, and physical stressors than girls. The right side of girls' brains develops more rapidly, which increases their resilience and ability to handle challenges. Baby boys also experience greater frustration and stronger reactions to stress between six months and one year of age, during which time they can benefit from additional nurturing.

Studies show that baby boys and girls are parented differently and that we need to provide boys with greater levels of warm and sensitive nurturing than girls. Contrary to our cultural perceptions and behavioral expectations of boys, the parent-child bond is extremely important to boys and necessary to help them develop feelings of trust and safety throughout life.

I NEED *MORE* NURTURING
AND CONNECTION
THAN BABY GIRLS,
ESPECIALLY IN THE FIRST
YEAR OF MY LIFE.

· 3 ·
RETHINKING
TODDLERS

The children in this chapter take us on a tour of their hearts and minds. They tell us how they think and feel and show us the world from their point of view. While most of us are familiar with the trials and tribulations of trying to reason with a two-year-old whose mind is not yet wired for logical thinking or trying to get a child with no sense of time out the front door, we are not as familiar with how challenging it can be to stand in that child's shoes.

Because children are so capable in so many ways and are able to push our buttons so easily, it is natural to assume that they are more advanced than they are and to set our expectations of their behavior accordingly. It is easy to forget that underneath that seemingly brilliant strategist is a toddler who lacks the mechanisms to fully understand, absorb, and stick to the rules of the game. The toddler brain is not yet fully wired with the capacities for reasoning, impulse control, delayed gratification, frustration tolerance, or empathy.

Learning how to behave in the world is like learning a new language. It takes time. Children need to hear what is expected of them over and over, and over, again. Acquiring these capacities is an ongoing challenge of the early years. How exasperating this can be for adults—and how frustrating it must be for children to be asked to do things they cannot yet do, or to stop doing things over which they do not yet have control.

Adults who model the desired behavior, but know that its acquisition for the toddler is a slow, steady, important, and often painstaking process, can facilitate the healthy arrival at the next stage. Standing with

toddlers as their allies and helping them deal with their disappointment, frustration, or hurt provides a template for what we hope they will be able to do for themselves down the line. Recognizing small steps as progress and acknowledging the hard work along the way can hasten the journey.

Today's technological advances can track how young children's brains develop. Just as they are so for infants, warm, loving responses foster confidence, curiosity, self-control, relatedness, and cooperativeness in toddlers—qualities that are considered to be more important to school readiness than knowledge of numbers and letters.

Underneath it all, toddlers want our approval. While they may test our limits, our love and acceptance are paramount to them. We have the opportunity to help them learn how the world works, to test things out, and to express themselves in the context of our relationships. If we allow ourselves to become stuck in the "punitive" role, we unfortunately rob both ourselves and our children of the profound growth that can come from a flexible, attuned, and sensitive dynamic. By spreading our arms wide enough to contain their behavior, stretching our understanding of their limits, and expanding our capacities to shepherd and guide them, we can begin to create a more child-friendly environment in which children can safely discover themselves and find their way in the world.

While this chapter speaks to keeping our expectations of toddlers realistic, it is just as important to keep our expectations of ourselves realistic. Parenting is a journey. We don't have to have the answers. We just need to stay open to the questions. We also need to nurture

ourselves and ensure that our own needs are met. Wrapping our arms around ourselves often, reminding ourselves of the amazing job we do every day, realizing that there is no perfect parent, and recognizing that everyone is discovering what to do as they go along can help relieve some of the pressure we often place upon ourselves. There is research that shows that reflecting on and making sense of our pasts can free us to be more present with our children and help us better nurture their futures.

We are our children's mirrors. Our daily responses to them will shape how they see and feel about themselves and who they will become. As one of the children in this chapter says, "When you say 'yes' to me, you help me say 'yes' to life." While there may be nothing more exhausting than dealing with a toddler, the more we understand their inner workings, the less work it might be. These pages are designed to help us step back, catch our breath, pat ourselves on the back, and behold the toddler—and ourselves—with our glitches and our glory.

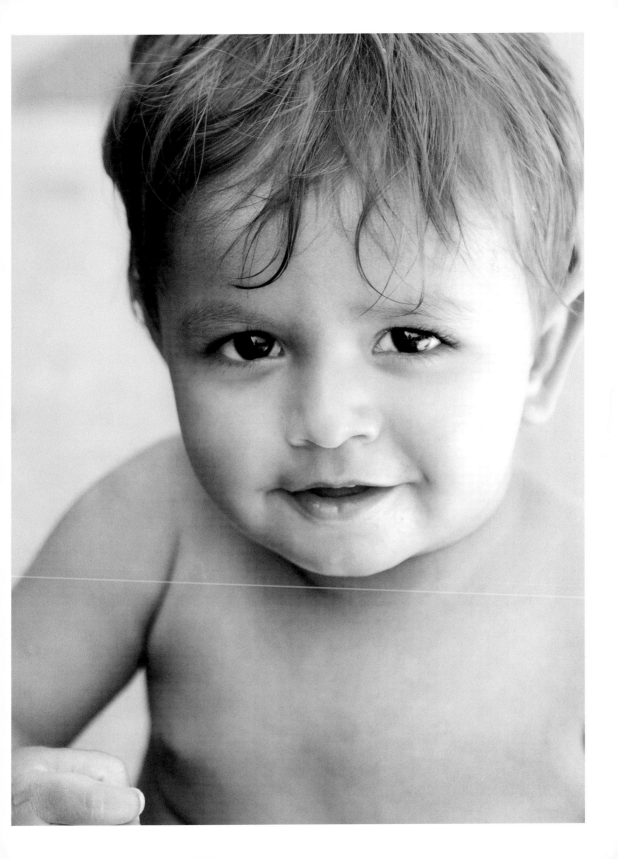

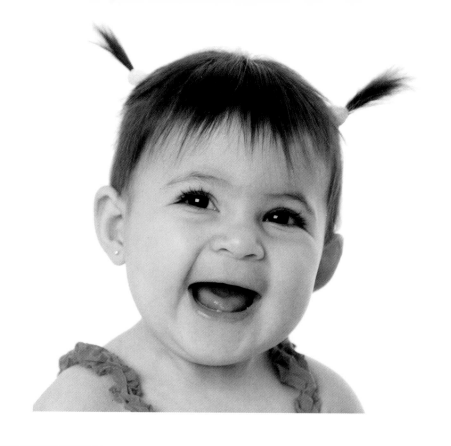

THIS IS NOT MY AGE
OF REASON. IT IS A TIME
FOR DECLARING MY
INDEPENDENCE!

EVERY SITUATION IS A CHANCE FOR A CHILD TO LEARN

Children crave learning and almost every experience is an opportunity for discovery. Toddlers learn through their senses. They come to understand how the world works by touching, tasting, pushing, pulling, knocking, and dropping. They also learn through repetition. Remembering this may help when, for example, your child drops her spoon over and over again and eagerly waits for you to retrieve it. While this ritual can be trying, it does have a purpose. Your toddler is learning the consequences of her actions: "When I do *this*, I cause *that* to happen." On a more abstract level, she is learning about gravity. She is also getting to see that things that disappear do come back, a concept she may be grappling with emotionally in terms of separating from you. While every household and every parent has limits, and sometimes a child's motivation is to test them, knowing there is usually a constructive and purposeful aspect to your child's experiments may offer a helpful perspective.

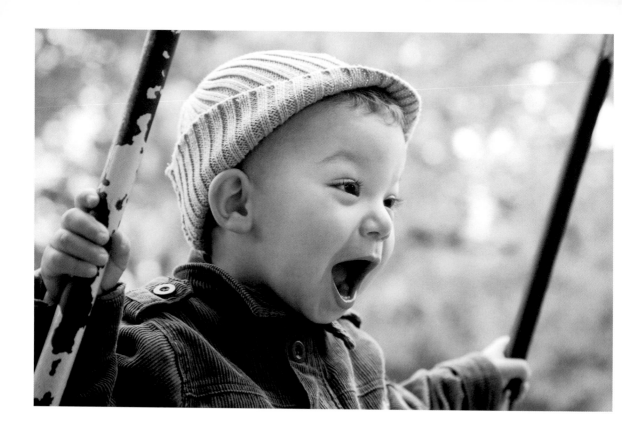

THE WORLD IS MY
CLASSROOM.

Children need to be busy and engaged. They need to discover the world and continually learn new things. A part of their brain releases dopamine, a hormone that drives them to explore and be curious. Dopamine wires them with a high need to interact and move about. Toddlers have a great need for learning through action; they also seek stimulation and structure. It is a good idea to always have something available into which they can channel their "seeking" energy. This will make them happier and your life easier.

Children are wired to learn. They have their own agendas. They seek experiences that will build upon their developmental capacities. We can provide them with learning materials and experiences, but it is important to step back and let each child explore at their own pace.

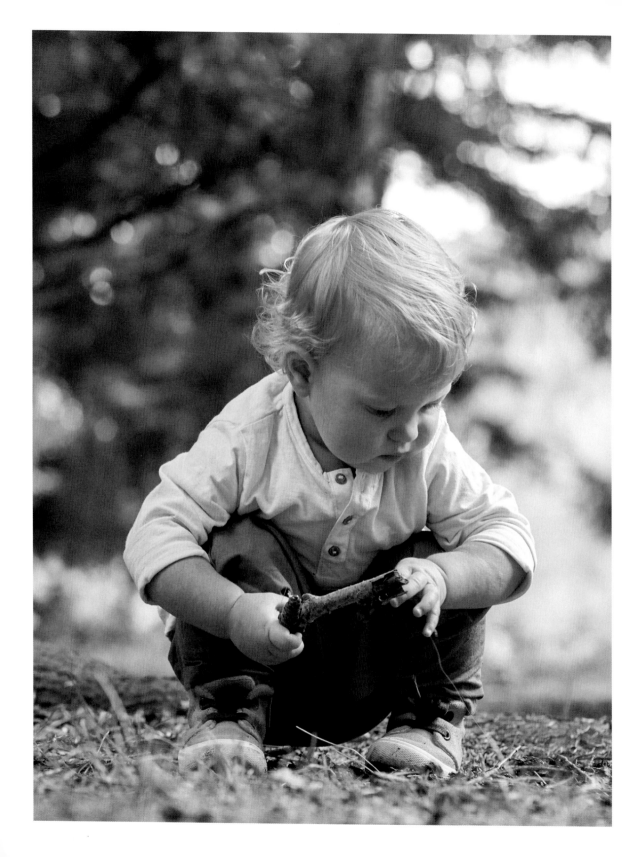

I NEED TO
STAY BUSY.

I NEED TO PLAY

Children know and seek the kinds of experiences that will help them learn the concepts with which they are grappling. They will choose to play with the materials that will help foster their development and teach them what they are ready to learn and explore. The "wait, watch, and wonder" approach to play can lead to new discoveries. If we show children how to use a toy, for example, they will use it just that one way. If, however, we let them explore and interact with the toy on their own, they are likely to discover several ways to play with it. Waiting to see what interests a child and how they approach interacting with an item, as well as asking them questions about what they are doing or thinking, can all expand the child's learning process.

I LEARN BY DOING.

I CAN'T THINK
ABOUT CONSEQUENCES.
ALL I CAN THINK ABOUT
IS NOW.

I SEE IT. I WANT IT.
IT'S MINE.

CHILDREN DON'T LEARN
SELF-CONTROL OVERNIGHT

Toddlers are driven by their impulses. Learning to control impulses is a long process and one of the major tasks of early childhood. Unfortunately, we cannot tell them not to do something and expect it to stick the first time. Toddlers need us to remind them, over and over again, what they can and cannot do.

Impulse control occurs in stages, not unlike learning to walk or to talk. It can be hard for us to keep this in mind when toddlers seem so capable and advanced in other ways. Yet, when we ask toddlers to stop doing something, they may be physically unable to do so, as their nervous systems are not yet fully developed. A young child may still be refining the neurological capacity to stop a movement once she starts it.

One of our key roles as adults during this time is helping toddlers control their impulses until they can do so for themselves. As anxious as we are for them to cooperate and as exasperating as it is to repeat ourselves over and over, redirecting them and reiterating the "rules" objectively may be the most effective means of helping them do so. If your child is about to bang a table, for example, you may need to physically redirect her to bang on the floor instead.

PATIENCE, PATIENCE

While setting limits is an essential part of child-rearing, it is important to try to do so without discouraging the child. A child's voracious appetite for exploring her world can provoke a cascade of restrictions about what is untouchable and off-limits.

However, if we react to toddlers' behavior with too many negatives, we run the risk of their beginning to doubt both their behavior and, eventually, themselves. Reminding ourselves of a toddler's limitations and understanding that learning self-control is a process can help us to interact with them with greater patience and understanding.

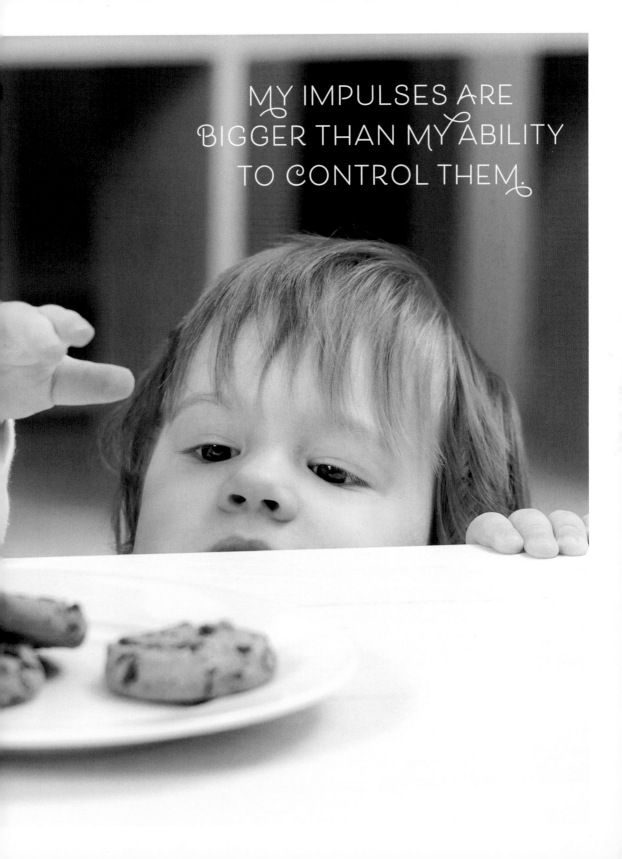

STAYING POSITIVE

During the second year of life, a parent's feedback is essential and will impact how a child feels about herself and her actions. If a child's behavior is too often met with "no," "don't," or "stop," we run the risk of their questioning the viability and "goodness" of their interest and actions and, more importantly, themselves, thus inhibiting their critically important exploratory behavior. These seeds of shame and doubt can last throughout life. The challenge at this period is to keep children safe, set limits, and help them follow guidelines without limiting or damaging their sense of themselves. There are ways to say "no" that are not shaming or cumulatively inhibiting of children's curiosity, interests, or desires.

When a child hears "yes" at home, she develops trust and confidence in herself and her actions that carries through all her behavior. We need to teach children without discouraging them. We need to show them the way without negating their sense of self. Redirecting and distracting children are also positive techniques.

MAKE IT EASY ON YOURSELF

"No" is a fighting word. Any sentence that begins with it, or other restrictions such as "you can't," can be predicted to bring on a heated reaction. There are so many ways not to trigger a child and end up in a battle of the wills. Parents need to choose their battles wisely; they can't struggle over everything. There are creative ways to set limits and guide children without starting World War III.

Rather than saying, "no candy," you can instead say, "Yes, you can have candy, but after you eat your dinner." When we challenge a toddler by saying "if you do that one more time" or "you can't do that," it is their nature to prove that they can. If we avoid challenging them, our time with our toddlers will be more rewarding.

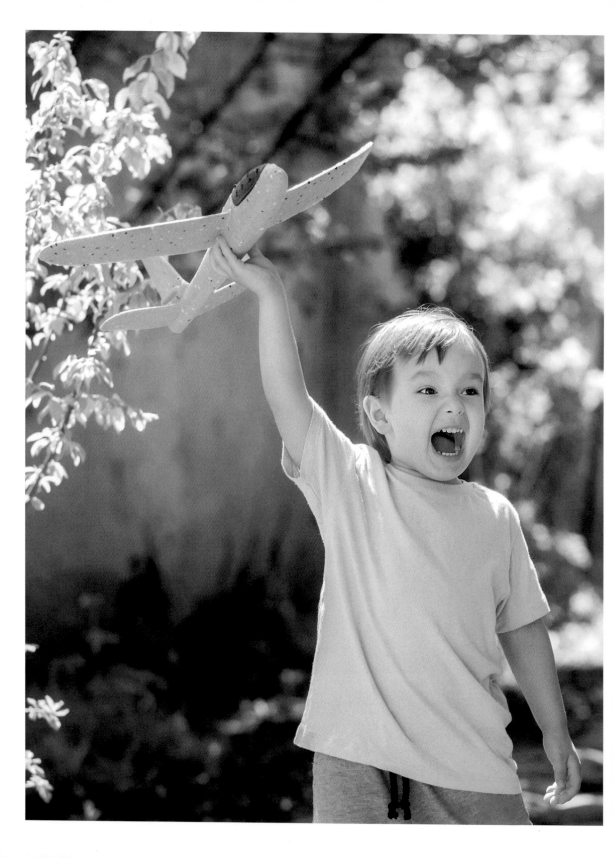

I CAN'T HURRY
AND
I CAN'T WAIT.

I AM NOT FULLY
EQUIPPED TO HANDLE
FRUSTRATION!

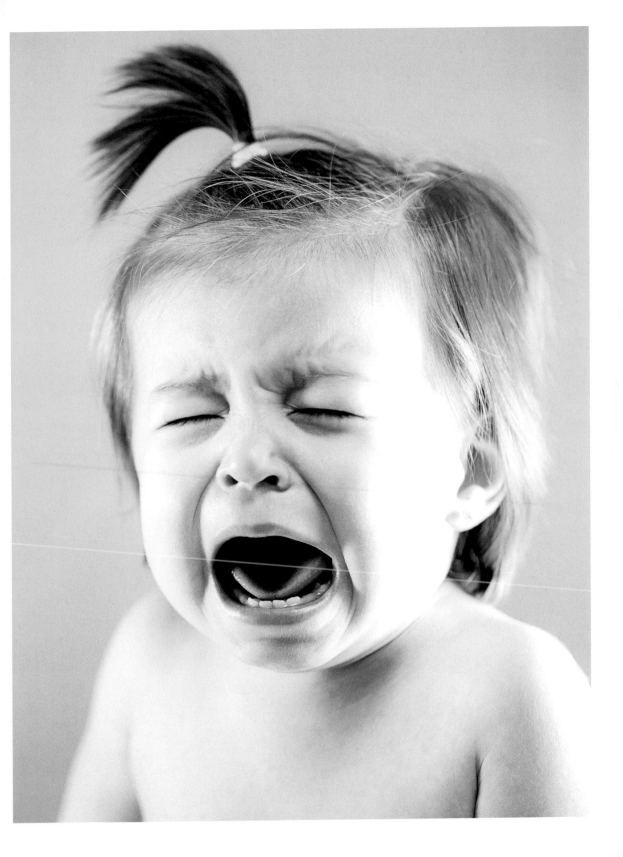

KNOWING WHAT'S POSSIBLE

According to a national survey conducted by Zero to Three, the majority of parents expect their children to be able to control their emotions by the age of two and to not have a tantrum when they are frustrated. This capacity is actually not fully developed until between three and five years of age. The study also found that parents often expect children to be able to share, control their impulses, or wait their turn long before they are developmentally capable of doing so. Setting realistic expectations can prevent a parent's disappointment and save a child from being asked to deliver the impossible.

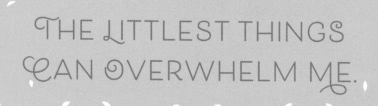

THE LITTLEST THINGS CAN OVERWHELM ME.

TANTRUMS COME IN ALL SIZES

Children have different types of tantrums for different reasons. When they are overwhelmed, it is very difficult for them to calm down on their own. They are still developing the capacity to manage stress, and their brains are not yet fully wired to do so. When the alarm system is triggered, stress chemicals can be released. Our best response is to soothe the child and help her to regain her equilibrium.

As frustrating as tantrums can be, they do have value. As we comfort and reassure a child, we are actually activating the higher area of their brain to develop pathways that will, over time, enable the child to gain control over the more primitive areas of her brain. Our sensitive, caring responses can also demonstrate to the child that they can be helped and comforted when they are upset.

While a distress tantrum signals that a child is overwhelmed and needs to be comforted, what has been referred to as a "Little Nero" tantrum signals that a child is trying to manipulate the parent to gain control and get what the child wants. Staying calm and rational and not giving in or giving too much attention to this kind of tantrum is an effective approach. Using some humor or being playful can often help deflect the child's intensity. In either type of tantrum, it is important for the child to feel that we can manage their experience and create a safe space for them.

I NEED TO BE HEARD.

WHAT DRIVES YOU
CRAZY NOW CAN DRIVE
ME TO SUCCESS LATER.

CURIOSITY

A toddler's first journey into academia is through their senses and the urge to explore. We must be thoughtful, as our response can have an impact on their future relationship to the learning process. If we make children feel wrong for following or expressing their curiosity, we run the risk of their beginning to feel wrong about themselves and their way of learning about and understanding the world.

If we fast-forward to how we would like to see our children in the classroom, most of us would say self-assured with their hands raised to answer the teachers' questions. That kind of confidence comes from a steady flow of reassurance, encouragement, and positive feedback at home.

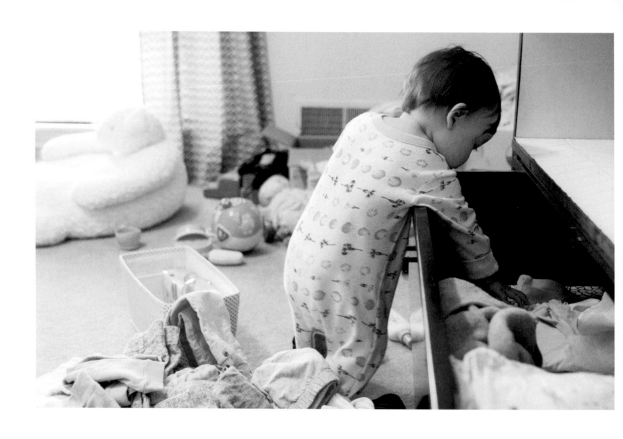

BEING MESSY CAN
LEAD TO IMPORTANT
DISCOVERIES.

I'M NOT MISBEHAVING.
THERE ARE JUST SO MANY
RULES TO LEARN.

SETTING REALISTIC EXPECTATIONS

Our children can seem so intelligent that we often begin to think that they are able to do more than they are capable of doing at this stage. We wouldn't expect a two-year-old to be able to do a geometry problem, since we know their minds are not yet ready. But when we ask them to sit still and listen, or to do something this instant, we may be asking for the undeliverable.

Toddlers' central nervous systems are still developing, which in fact makes it extremely difficult for them to respond immediately to our requests. For example, if we ask them to "Come here right away!" or "Stop doing that this minute!," they may not yet be able to do so. It takes time for our request to travel through their senses up to their brain, where it is processed, and then returns through nerve impulses back to redirect their activity.

Understanding this neurological limitation can help us be more patient as well as recognize that toddlers are not just being obstinate or oppositional. Knowing their capabilities can help us set realistic expectations and avoid unnecessary battles. It can also help us feel less frustrated, disappointed, or angry because they seem to be not listening. While toddlers are not always willing to do what we ask, we can usually work with them to redirect their activity. They need to hear our requests repeatedly and over time. Exercising patience and modeling the desired behavior can help form the neural pathways that will enable a toddler to respond more quickly and repeatedly.

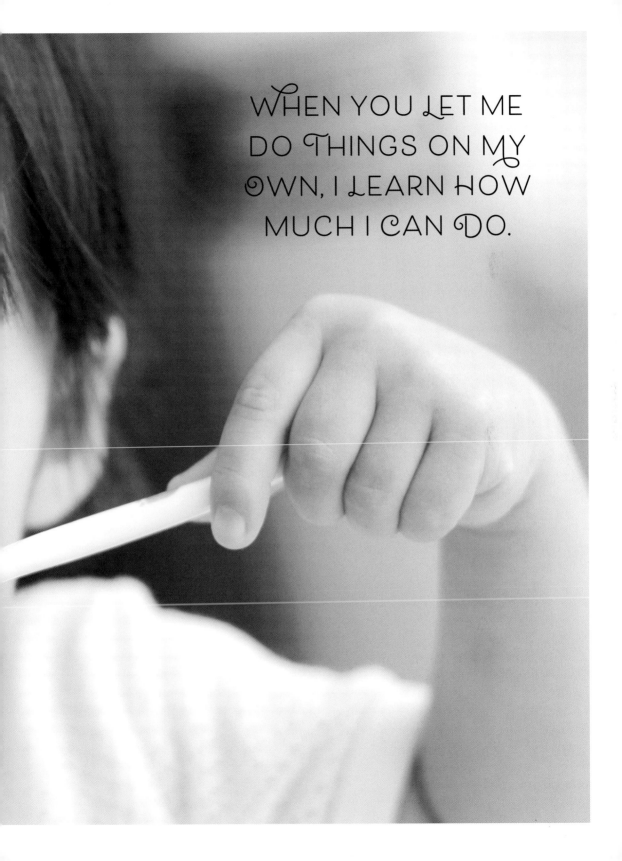

WHEN YOU LET ME DO THINGS ON MY OWN, I LEARN HOW MUCH I CAN DO.

A MIND OF MY OWN!

We often hear parents saying in frustration that their young child has a mind of his or her own! When parents recognize their young children as individuals with their own thoughts, feelings, and interests, the parent-child bond has been found to grow stronger, cognitive development is enhanced, and the child's ability to understand and manage their own behavior becomes more developed.

Conversely, when parents can reflect on their own childhoods and make sense of their past experiences, it can greatly improve their capacity to develop a strong, secure relationship with their children.

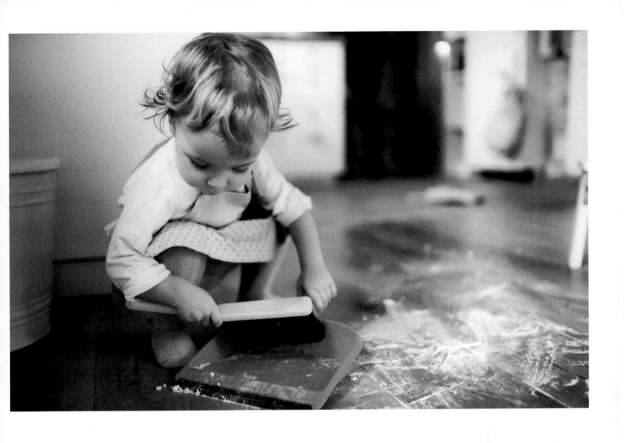

HAVING A JOB BUILDS
MY CONFIDENCE. IT MAKES
ME FEEL IMPORTANT AND
LIKE I BELONG.

HELPING TODDLERS LISTEN

Toddlers are masters at tuning parents out. They're not necessarily ignoring adults on purpose; rather, they often get completely absorbed in what they are doing at the moment, making it difficult for them to shift gears. When we would like a toddler to do something, we can help her focus on our words by getting right next to her and making eye-to-eye contact or touching her gently on the shoulder. Calling out across the room will most likely be ineffective and leave us escalating our pitch to no avail.

Toddlers live in a time zone all their own. They seem incapable of hurrying and unable to wait. Giving them advance notice of transitions can be helpful: "In five minutes we'll need to put the puzzles away to get ready for dinner." While your toddler may still protest, your notice should help her tune in and respond. Keeping our expectations realistic and our toddlers' capacities in mind can help make these trying times less frustrating.

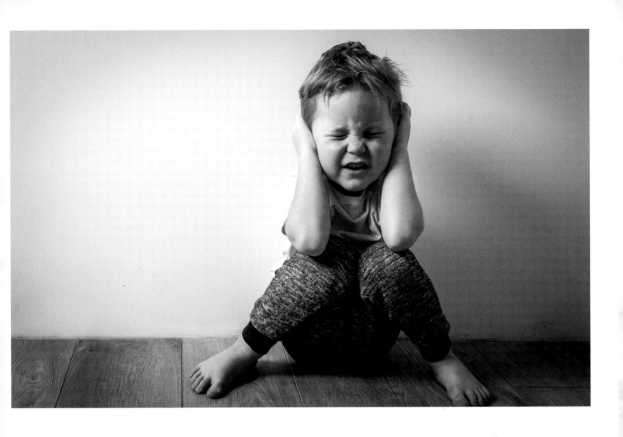

TOO MANY
DEMANDS MAKE ME
WANT TO TUNE OUT.

TOO MANY "NOS"
MAKE ME DOUBT
MYSELF.

LEARNING TO LISTEN
TAKES TIME. I NEED LOTS
OF PRACTICE.

MY MIND GROWS WHEN OUR
HEARTS ARE CONNECTED

Today, with the explosion of information on how children's minds develop and the greater understanding of how cognitively capable they are, there is a great deal of pressure on parents to foster intellectual development. Studies show that children's brains develop through relationships, and that reading children's cues and responding to them are key to brain development. What the research tells us is that children's brains develop through their emotional connection to their parents. As one of the toddlers says, "My mind grows when our hearts are connected."

When children feel secure emotionally and strongly attached to their parents, and when parents understand and respond to their children's cues, optimal learning takes place. When the attunement is broken, leaving the child feeling disconnected, it becomes hard for the child to focus and process what others are saying. The disconnection releases stress hormones in the child's system, setting off a series of negative emotions. At this point, it is most important for parents to restore that connection first. Verbal apologies, soothing words, or warm physical contact from the parents can actually stop the flow of cortisol, repair the relationship, and allow the child's brain to return to higher functioning.

In our anxiety and desire to ensure our children's good behavior, we often get lost in the loop of managing their behavior, losing sight of the wonderful opportunities we have to help our children emerge from the toddler years with autonomy, self-esteem, mastery, and competence. We forget that we can work to instill in them a belief in their innate goodness and capacities, fostering a positive self-image that will last a lifetime.

The greater our understanding is of what we can and cannot expect from toddlers, the more successful we will be in our interactions with them and the less frustration and disappointment we will experience. Additionally, our increased understanding will make toddlers' day-to-day experiences much easier, which is a key to continued healthy development.

THE POWER OF APOLOGY

In the course of our daily interactions with children, we may end up saying things that we regret due to frustration or exhaustion. Despite our best intentions, our tolerance threshold can be reached. Apologizing to a child during these times is extremely valuable. When we acknowledge our regret, we are letting children know that it is OK to make mistakes. We are telling them they don't have to be perfect and neither do we. By taking positive steps to counteract our action, we are modeling mature behavior and teaching them about responsibility and turning a situation around.

The act of apologizing can also help heal the damage a stressful encounter between a parent and child may cause. When we stop to apologize, we can actually curb the negative effects of stress. Apologies from both children and parents teach an important lesson and create a win-win situation.

SHARING CAN BE HARD

Sharing doesn't come easily to children, as they are still establishing a sense of self. Until the age of three, a child is in the egocentric phase and sees everything from her point of view. She is working very hard to find her own balance and is not yet ready to take others into account. Her perspective of "me, my, and mine" is not really a selfish one; rather, it is an expression of her efforts at autonomy. While she may share occasionally, expecting her to do so on a regular basis may be unrealistic.

During this time, it is helpful to encourage, model, and plant the seeds for sharing. If a playmate wants to play with your child's favorite toy, for example, finding a substitute toy for the friend and asking your child to let her friend play with her coveted toy later establishes a pattern for sharing but still allows your child a sense of control over her belongings. Your child's toys are symbolic of herself at this age. Expecting her to share them too soon may leave her feeling out of control and unable to hold on to what is hers. Being patient and gently guiding her in the right direction can help pave the way to generosity.

SHARING CAN BE
HARD. IT'S NOT THAT
I AM SELFISH. I AM
STILL WORKING ON MY
SENSE OF SELF.

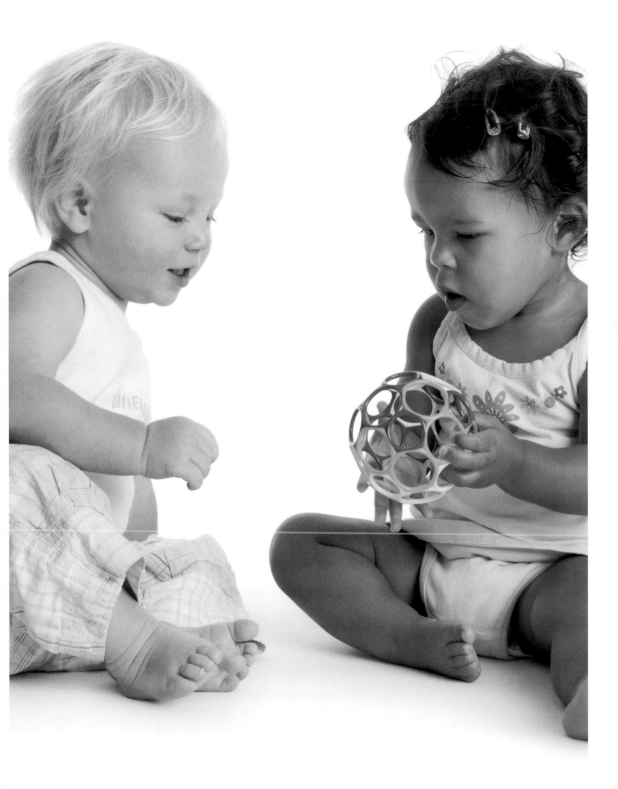

THE TROUBLE WITH TIMEOUT

Timeouts can send negative messages to children about themselves and their feelings. Children often act out because they are feeling stressed, they need comfort or connection, or they can't manage a "big" feeling. When we tune in and get a sense of what might be driving their behavior, we may be able to reassure them or meet their need without causing additional stress from a forced separation. A time-out can add more stress to an already overstressed child. The more stressed the child feels, the more stress hormones she will release, making a resolution more difficult. Isolating can feel very scary and punitive to a child. We need to let children know that we can handle their feelings and, again, that we can create a sense of safety for them.

I CAN'T HELP MY FEELINGS,
BUT I COULD USE YOUR
HELP MANAGING THEM.

I SEEM SO GROWN
UP SOMETIMES THAT
PEOPLE EXPECT TOO
MUCH FROM ME.

WHEN YOU LISTEN
TO ME, YOU HELP ME
FIND MY VOICE.

BREAKING THE
"IF ..., THEN ..." CYCLE

How many times do we hear ourselves telling children as they grow older, "If you do that one more time, I'm going to ..." and, as is predictable, the child does it one more time and we either carry out our threat, feeling terribly guilty, or back down, leaving an unresolved situation.

When we threaten, a child will generally take it as a threat to her self-respect and feel the need to assert her will and repeat the action.

One alternative to this self-defeating exchange is to state the fact to a child, explaining the rules objectively. If, for example, your child is squeezing glue onto his clothes, you might say, "Glue is for holding things together, not for putting on your clothes. Let's use the glue to do an art project." If your child continues to put glue on his clothes, you can give him a choice: "You can use the glue on the paper or we'll put it back in the cabinet and you can try again another time. You decide." This way you are communicating the rules without threatening or damaging his self-esteem. You are demonstrating how the world works without making him wrong. You have set a limit in a way you do not have to later regret or feel guilty about.

Toddlers have voracious appetites for exploring their world. While it's essential to set limits, it's important to try to do so without discouraging them. If we react to their explorations with too many negatives, we run the risk that they'll begin to doubt their behavior and eventually themselves. Curiosity is the driving force behind their growth and development. When toddlers hear "yes" at home, they develop trust and confidence in themselves and their actions that carry through all their future behavior. We need to teach toddlers without discouraging them, to show them the way without negating their sense of self.

WHEN YOU ASK ME WHAT I THINK, I LEARN THAT MY IDEAS ARE IMPORTANT.

WHEN YOU SAY "YES"
TO ME, YOU HELP ME
SAY "YES" TO LIFE.

THE POWER OF
POSITIVE LANGUAGE

Today, MRIs and other scans can confirm that the language we use has a strong impact on children's brains. Neuroscientists have discovered that just hearing "no" and other restrictive comments can trigger the primitive area of the brain and release stress and other anxiety-producing hormones. Conversely, hearing "yes" and a range of other positive comments builds the areas of a child's brain that enhance cognitive functioning, including reasoning, planning, and problem solving. Positive words also reinforce "good" behavior and encourage curiosity, self-esteem, and resilience, key factors contributing to positive life outcomes.

Hearing "yes" also engages the neural circuits that enable social engagement, helping children connect to others. Encouraging words trigger the development of the higher brain functions and enhance curiosity, compassion, and a range of other positive characteristics. "Yes" and other affirming words activate circuits that lead to the ability to handle challenges and feelings of control over life.

IT'S IMPORTANT FOR
ME TO SAY "NO!"
IT HELPS ME BECOME
MY OWN PERSON.

SAYING "NO" IS A HEALTHY SIGN

While it may be exasperating to hear toddlers say "no" to everything asked of them, it is actually a healthy sign that they are beginning to separate from you. As a toddler approaches two, she begins to experience her autonomy and to develop a sense of her own identity. This separation is an essential step in development, and your support of it is critical. Allowing her to feel her separateness and express her "power" is positive and encourages the development of a healthy ego. Toddlers may be saying "no" even when they mean "yes." Making light of their declarations and responding with humor whenever possible are ways of dealing with this trying period. Giving your toddler specific choices may be helpful. For example, by asking "Do you want to wear the red sweater or the blue sweater?" rather than "Do you want to wear a sweater?" you are minimizing the chances of a negative response. You are also giving your child a sense of control over her own life, which is important in this difficult but essential transitional stage into selfhood. A battle of the wills, while sometimes seemingly inevitable, is invariably nonproductive. Remembering that your support and approval are the building blocks of your child's developing sense of self can fuel your patience.

I NEED TO BE
REMINDED OF
OTHER PEOPLE'S
FEELINGS.

I AM NOT THE ONLY ONE.

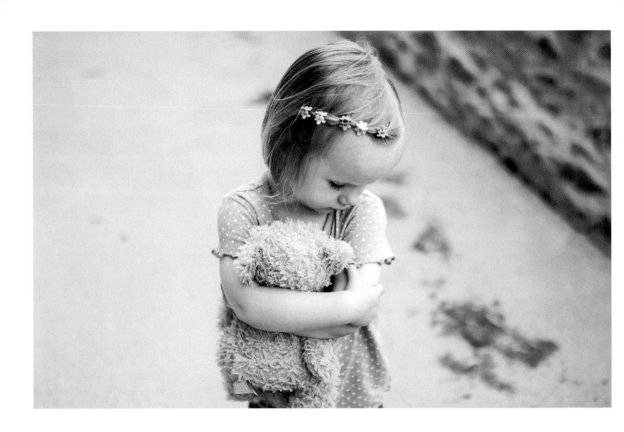

MY THINGS ARE
VERY IMPORTANT
TO ME . . .

... AND A STAND-IN
FOR YOU WHEN YOU
ARE NOT HERE.

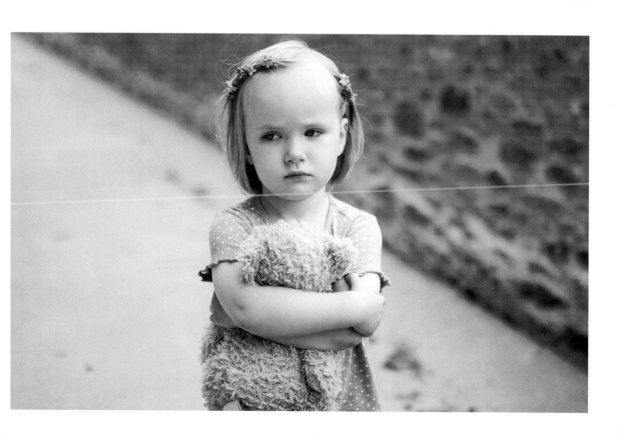

WHEN YOU CELEBRATE
ME, YOU HELP ME
CELEBRATE MYSELF.

CONCLUSION

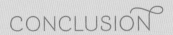

All parents have the potential to shape how their children feel about themselves, how they treat one another, and what they bring to the world. Study after study has shown that the power of a parent's love can support children in becoming their optimal selves.

The new insights from science allow us to replace many of the past ideas about children that have influenced how we parent. A wide-open road lies ahead of us. We have the knowledge of what it takes to increase the likelihood of positive outcomes in all areas of children's lives.

We have traditionally underestimated the capacities of newborns and infants and overestimated those of toddlers. The children in *Shaped by Love* have shown us what they are capable of during different stages of development. The neuroscience has given us a road map of what children need in the first years of life for optimal brain development. This knowledge can enable us to foster their growth and help them flourish in every way.

If we let the children and the science guide us and if we listen to our hearts, we can raise children who experience feelings of well-being, happiness, peace, generosity, and concern for others. Our nurturing interactions can foster their social, emotional, and cognitive development. The way we love babies from the start will impact how they love themselves and others throughout life.

With love, we can raise children who are able to excel in every area and become their best selves.

This capacity for love is a gift all parents can give to their children. This gift is not dependent on external factors; it is an expression of the love in every parent's heart. The profound impact that love can have speaks to the importance of supporting parents so that they can care for themselves, thus enabling them to provide their children with a strong foundation. The more we can establish an understanding of what babies need, as well as the social support that parents need, we can begin to create a more peaceful, productive, and harmonious world.

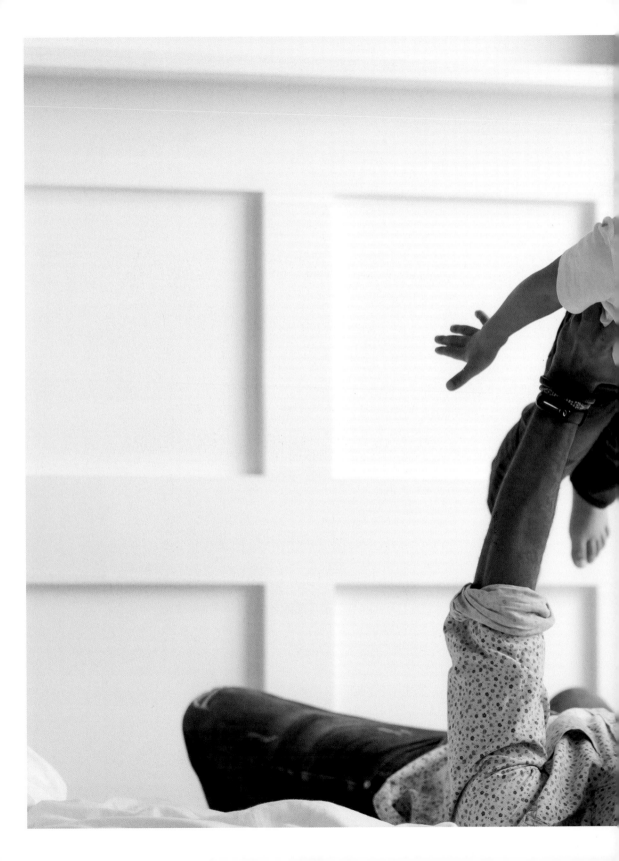

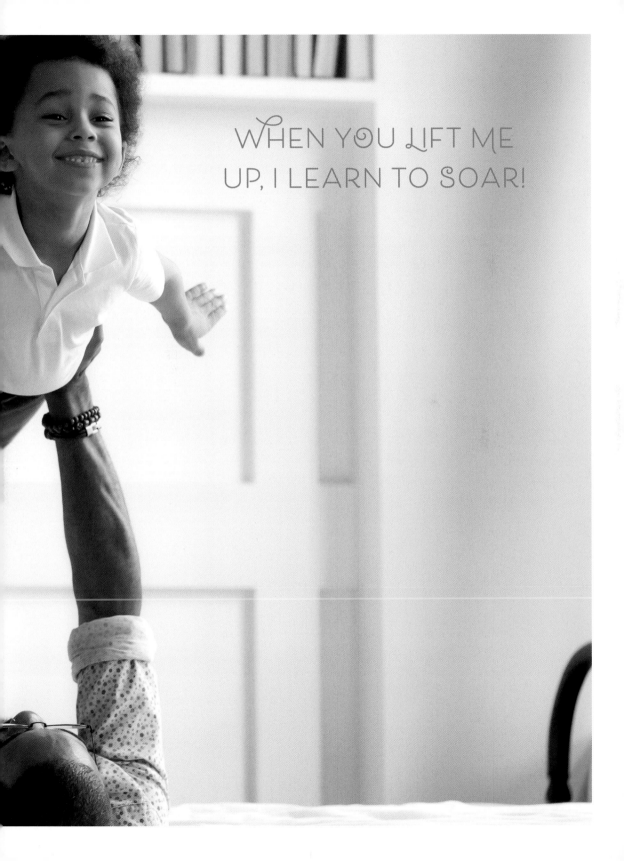

WHEN YOU LIFT ME UP, I LEARN TO SOAR!

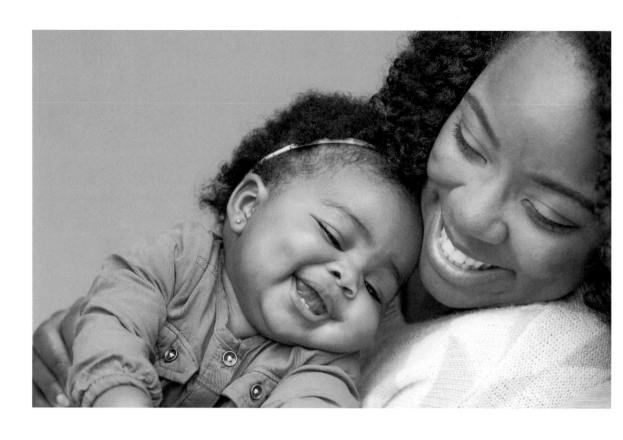

KNOWING I CAN COME
BACK TO YOU ...

... HELPS ME
GO OFF ON MY
OWN.

PHOTO CREDITS

FURTHER READING

WEBSITES

American Academy of Pediatrics
https://www.aap.org

The Association of Prenatal and Perinatal Psychology and Health
https://birthpsychology.com

Attachment Parenting International
https://www.attachmentparenting.org

Center for the Developing Child, Harvard University
https://developingchild.harvard.edu

Child Study Center at the Yale School of Medicine
https://medicine.yale.edu/childstudy

Circle of Security International
https://www.circleofsecurityinternational.com/resources-for-parents

Parenting for Brain
https://www.parentingforbrain.com

Too Small to Fail
https://toosmall.org

Zero to Three
https://www.zerotothree.org

BOOKS

Axness, Marcy. *Parenting for Peace: Raising the Next Generation of Peacemakers.*
Colorado: Sentient Publications, 2012.

Karen, Robert. *Becoming Attached: First Relationships and How They Shape Our
Capacity to Love.* Oxford: Oxford University Press, 1998.

Seigel, Daniel J., Jonathan Baylin and Daniel A. Hughes. *Brain-Based Parenting:
The Neuroscience of Caregiving for Healthy Attachment.* New York: W.W. Norton
& Company, 2012.

Sunderland, Margot. *The Science of Parenting: How Today's Brain Research Can Help
You Raise Happy, Emotionally Balanced Children.* New York: DK Penguin Random
House, 2016.

ACKNOWLEDGMENTS

Many friends and family members gathered around *Shaped by Love* to help birth it. My brother, Craig Hatkoff, is truly the book's godfather. The offer from my publisher to acquire the book came just days after I lost my sister, Susan Patricof, and it felt like my siblings guided its creation and supported me along the way. My brother-in-law, Alan Patricof, shared his space, his savvy, and his enthusiasm.

My deepest gratitude to Susan Wolf, the guardian angel of the book. Thanks also to Linda Clark, Merle Bruno, Arlene Hellerman, Satya Kirsch, Susyn Schops, Dr. Ann Abram, Marcia Patricof, Elizabeth Lizan, Robyn Scholer, Gay French-Ottaviani, Courtney Dawson, Michael Thorton-Smith, Kathryn Burns, and Brenna Raffe who all gave generously of their time and input.

I had an amazing team who brought their extraordinary capacities to the book: Missy Hargraves contributed her astute editorial skills and Nicole Widenberger brought her brilliant eye to every detail.

I am deeply indebted to my editor, Shawna Mullen, and to Wayne Gurreri at Abrams.

My heartfelt thanks to my lawyer, Jan Constantine, who was always there for me no matter the time or day.

Writing the book was a profound experience. Having the support of a village reminded me of the beauty and potential of working together to make the world a better place. It also showed how important love is at every age and how we all flourish when we feel supported. I hope the book can create a better world for our children and a greater realization of ourselves.

My work has been informed and inspired by numerous thought leaders, too numerous to list them all, but including Mary Ainsworth, Beatrice Beebe, John Bowlby, T. Berry Brazelton, Don Dinkmeyer, Peter Fonagy, Magda Gerber, Haim Ginott, Marshall Klaus, Ron Lally, Nina Lief, Jeree Pawl, Daniel Siegel, Jack Shonkoff, Margot Sunderland, Allan Schore, Nancy Samalin, Arietta Slade, and D.W. Winnicott.

My gratitude to all for raising awareness of the importance of the first three years of life and of what children need for optimal development.

ABOUT THE AUTHOR

AMY HATKOFF is an author, educator, and advocate for children and families. She is the author of *You Are My World: How a Parent's Love Shapes a Baby's Mind* and coauthor of *How to Save the Children*. She worked on *The First Years Last Forever*, a component of Rob Reiner's video series *I Am Your Child,* and coproduced the award-winning documentary *Neglect Not the Children* hosted by Morgan Freeman.

Hatkoff is also the author of *The Inner World of Farm Animals: Their Amazing Social, Emotional, and Intellectual Capacities*. The book sheds a new light on the capacities of farm animals and makes a plea for treating them with compassion and respect.

Hatkoff has taught child development and family support at Bank Street College of Education's Continuing Professional Studies program and has led workshops for professionals and parents in the United States and abroad. She received a BA in Child Psychology and Early Childhood Education from Hamilton College and attended a master's program in Parenting Education and Family Support at Wheelock College, as well as a postgraduate program at the Infant-Parent Study Center in New York City. She continues to work on a range of projects to raise awareness of how to foster children's optimal well-being.

Editor: Shawna Mullen
Designer: Diane Shaw
Design Manager: Danny Maloney
Managing Editor: Glenn Ramirez
Production Manager: Larry Pekarek

Library of Congress Control Number: 2021946858

ISBN: 978-1-4197-5888-1
eISBN: 978-1-64700-552-8

Text copyright © 2022 Amy Hatkoff

Cover © 2022 Abrams

Printed and bound in China
10 9 8 7 6 5 4 3 2 1

Abrams books are available at special discounts when purchased in quantity
for premiums and promotions as well as fundraising or educational use.
Special editions can also be created to specification. For details, contact
specialsales@abramsbooks.com or the address below.

Abrams® is a registered trademark of Harry N. Abrams, Inc.

ABRAMS The Art of Books
195 Broadway, New York, NY 10007
abramsbooks.com